✳ SPECIAL EFFECTS ✳
LETTERING AND CALLIGRAPHY

SPECIAL EFFECTS LETTERING AND CALLIGRAPHY

A BEGINNER'S STEP-BY-STEP GUIDE TO CREATING AMAZING LETTERED ART—EXPLORE NEW STYLES, COLORS, AND MEDIUMS

GRACE FRÖSÉN

Quarto.com
© 2023 Quarto Publishing Group USA Inc.
Text and Illustrations © 2023 Grace Frösén

First Published in 2023 by Quarry Books, an imprint of The Quarto Group,
100 Cummings Center, Suite 265-D, Beverly, MA 01915, USA.
T (978) 282-9590 F (978) 283-2742

Quarry Books titles are also available at discount for retail, wholesale, promotional, and bulk purchase. For details, contact the Special Sales Manager by email at specialsales@quarto.com or by mail at The Quarto Group, Attn: Special Sales Manager, 100 Cummings Center, Suite 265-D, Beverly, MA 01915, USA.

10 9 8 7 6 5 4 3 2 1
ISBN: 978-0-7603-8054-3

Digital edition published in 2023
eISBN: 978-0-7603-8055-0

Library of Congress Cataloging-in-Publication Data is available.

Design and Layout: Amelia LeBarron

Printed in China

FOR *Joonas*

my husband
& best friend

FOR *Renée*

and our
arty afternoons

FOR *Tim*

and our
coffee chats

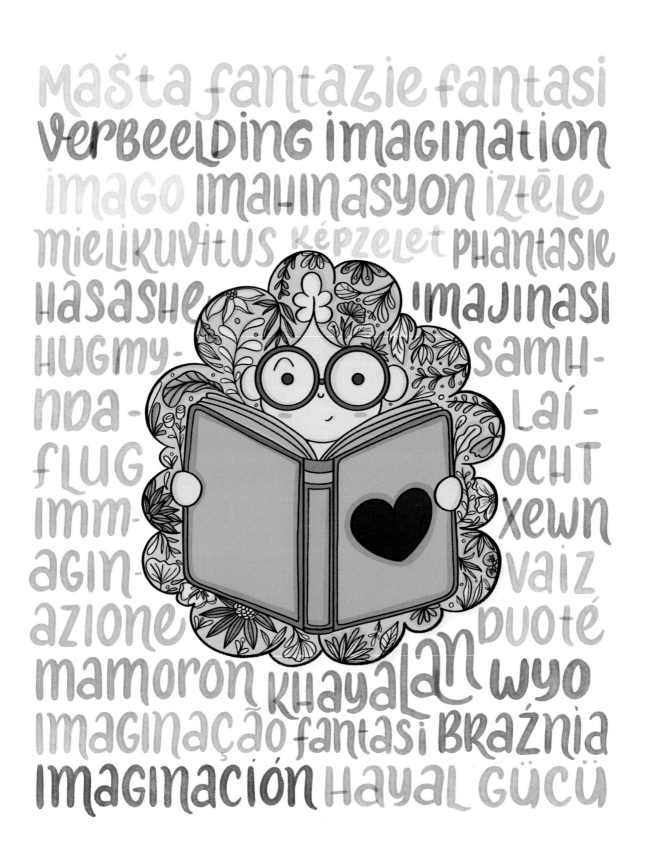

CONTENTS

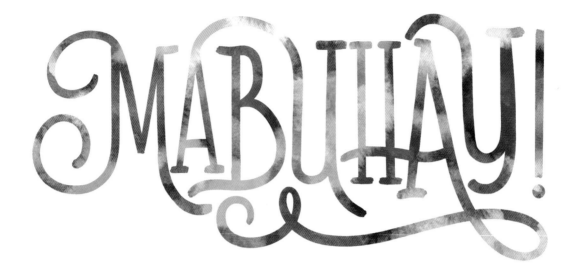

↑ Tagalog: Long Live

MY CREATIVE JOURNEY

For as long as I can remember, art has been my escape. Growing up, I would spend all day drawing my adventures with dinosaurs in between having pretend underwater tea parties with mermaids. There was always something freeing about creating art as a child. My imagination wasn't bound by reason. Not only did I believe that everything I created was a masterpiece, but they were also always fridge-worthy! But as I reluctantly became an adult, I slowly forgot about the magic of art. Fantasy worlds were slowly replaced with illustrating precise charts and organized notes. I abandoned art and only found it again in my thirties. I picked up my magical pen once again, and I haven't looked back since.

I rediscovered my fascination with whimsical doodles and had a newfound interest in lettering and calligraphy. It was an expressive way to draw the letter shapes, making them into a unique visual art form on their own.

Finding my love for art again has renewed my belief that everyone can make art. Yes, this includes even the ones who say they can't draw to save their life. I hope you find something in this book that ignites your passion to try something new or rediscover something that you once thought was lost.

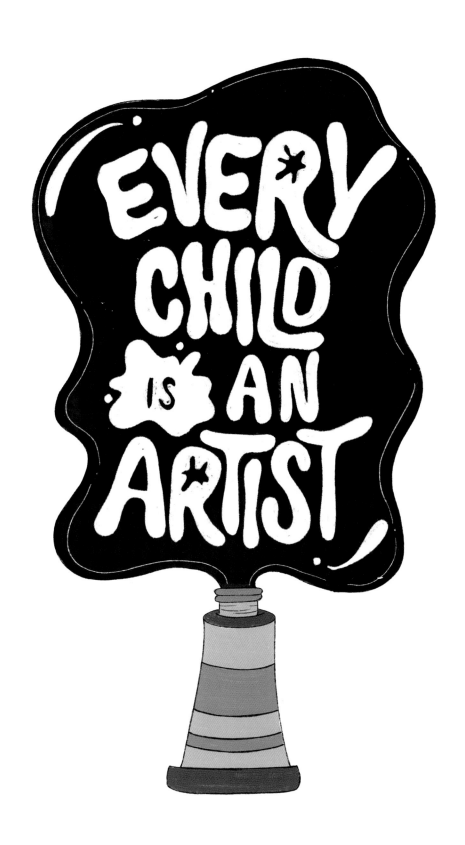

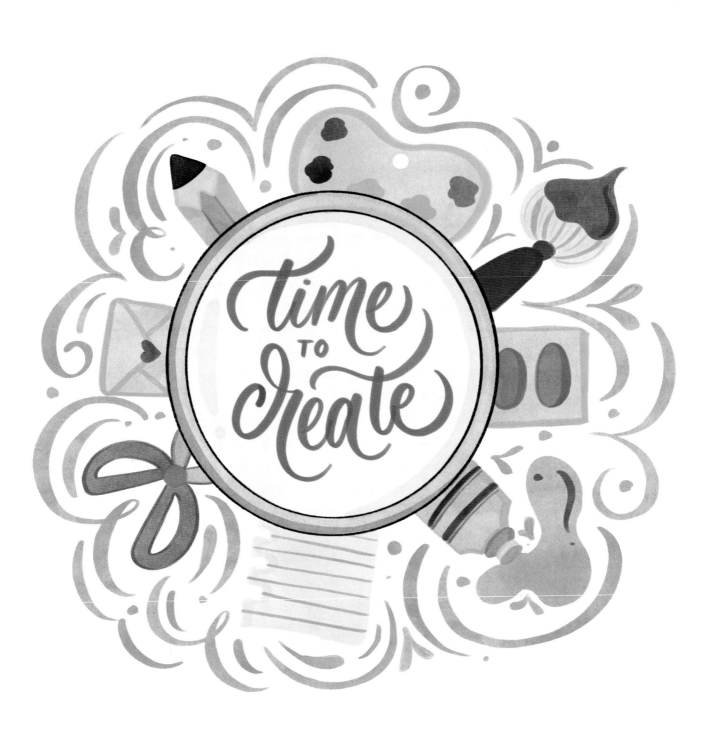

· 1 ·
GETTING
STARTED

Picking the right art supplies can be exciting, but also over-whelming. I believe that just like a magical wand, the pen chooses the artist. Although it can take a bit of trial and error to find the materials that are right for you, being surrounded by a variety of pens and testing out each one is my idea of heaven.

In this chapter, I will walk you through my favorite art materials. But you definitely don't need to own every single thing on the list in order to start making art.

In my basic pencil kit, I always have a **pencil, eraser, black fineliner,** and **dotted paper**. Even if you only have these materials to start out with, you'll be creating an abundance of amazing artwork in no time.

Along with art materials, you'll also need to bring along **your imagination**. One of the most important things that I've learned from being a self-taught artist is being comfortable with experimenting freely, even when there are rules to follow. Imagination comes in handy, especially when you're brainstorming new ideas.

When I started making art again in my thirties, I felt a little embarrassed to discover that the things I loved drawing the most were cartoons and cute things. I had this belief that as an adult, I should be making thought-provoking paintings and incredible portraits. But art knows no age. So give yourself permission to explore and own your style. For everything else, here's your artistic license.

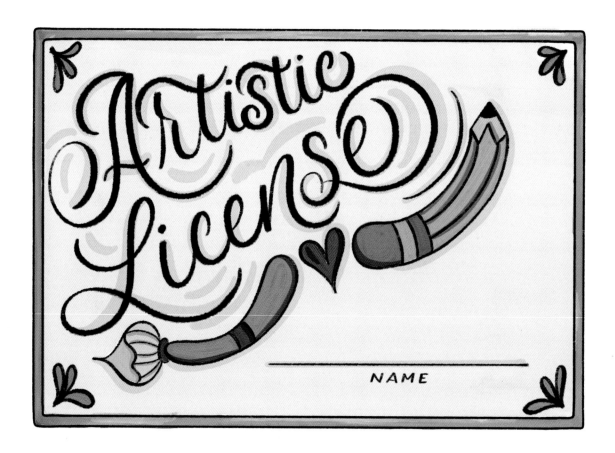

pencil

dotted paper

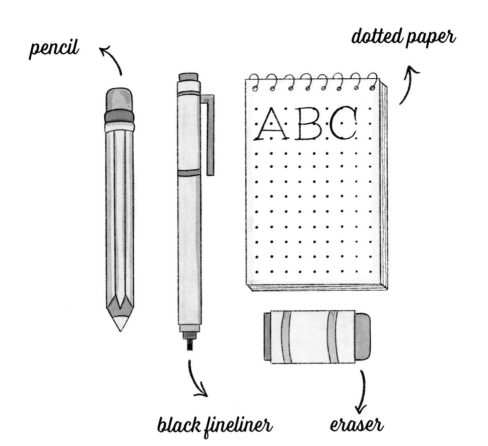

A·B·C

black fineliner

eraser

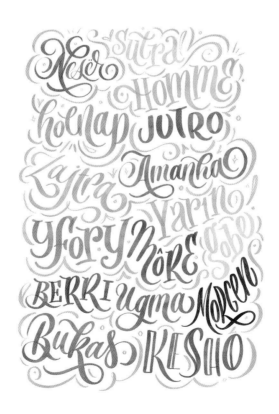

13

PENCIL AND ERASER

As I previously mentioned, you can do wonderful things with just a pencil and an eraser. They are the basic tools that we all learned to use growing up. I like using a Uniball Kuru Toga Mechanical Pencil because it's convenient and mess-free. To go with it, I use a Faber-Castell Dust-Free Art Eraser. It's very important to find an eraser that does the job properly so that there are no smudges left after erasing.

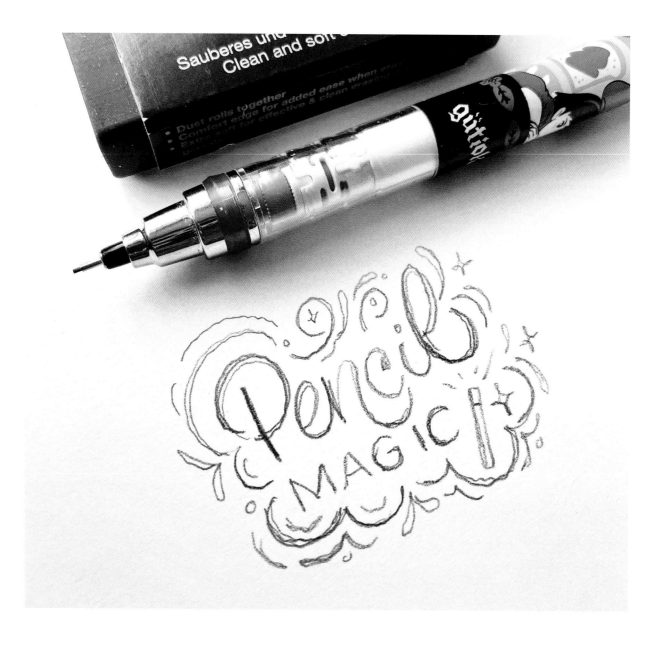

BLACK FINELINERS

Inking is an important part of making art pieces. Felt-tip fineliners in a variety of different size tips are helpful for that. I like using the Sakura Pigma Micron Pens. They are waterproof and come with archival ink, so your artwork won't fade and will last longer. They also offer a useful assortment of pen tip sizes. There are bigger tips for covering larger areas and making very bold lines and smaller tips for detailed work. My most basic kit has four tips: 005MM, 0.2MM, 0.5MM, and 0.8MM. I find that those four sizes cover all my art needs.

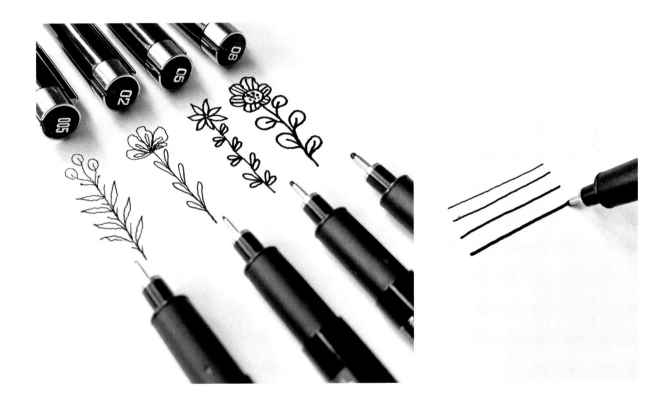

Gel pens are useful when you want to add a glittery, shiny component to your artwork. My favorite ones are these Sakura Gelly Roll Pens. The gel pen ink shows up on black backgrounds, so it makes it a good companion to the black fineliners when you want to highlight something.

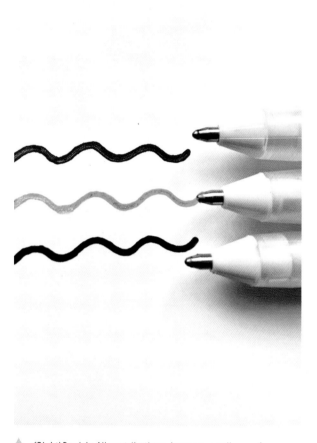

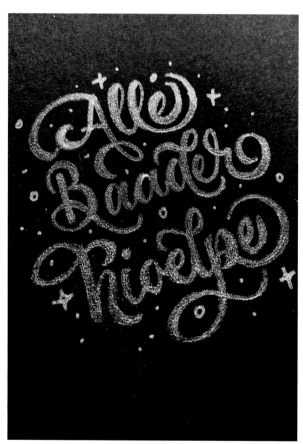

↑ *(Right)* Danish: All contributions, however small, are of use

If you want to show the sheen of the metallic colors even better, use black paper. I made the lettering piece above (right) using gel pens from Karin Markers.

I went over the letter downstrokes with the gel pen a few more times to make them thicker and achieve some line variation.

COLOR CHANGES

Some gel pens have different effects of their own. The Sakura Gelly Roll Gold Shadow Gel Pen turns from its original color into gold. I used it on some shiny, coated paper, which makes the ink react slower because it doesn't absorb the ink in its fibers. Instead, it pools on the surface. Here's how it looks like mid-transition on coated paper. Why not experiment and try out some gel pens and see how they react to different types of paper?

Here's the same pen on black cardstock paper. Compared to the coated paper, the ink changes quicker as soon as the letter is written. The end result shows the entire word completely in gold.

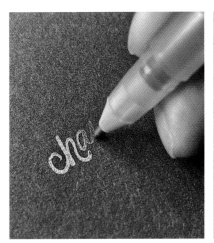
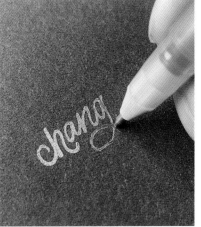
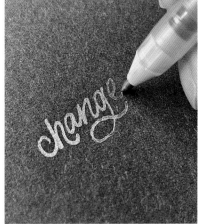

RAINBOW MULTICOLORED PENCILS

These pencils are a lot of fun because they already have their very own built-in special effect. Unlike regular colored pencils, the tip of these rainbow pencils contains a mixture of different vibrant colors and shades, producing unique, eye-catching effects with every stroke.

Part of the fun for me is not knowing the exact color combination that's going to transfer from pencil to paper, which makes it the perfect tool to use when I'm warming up, trying to get my creative juices flowing, and experimenting. It's simultaneously relaxing because it's a tool for playing around as well as exciting because the colors are always a surprise.

Although precision isn't the main goal when using these pencils, there are certain things you can do to make the experience of using them easier, so you get the desired rainbow effect.

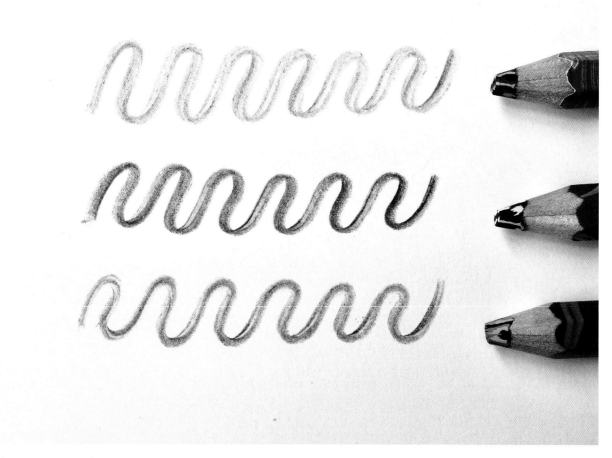

↑ I like using Koh-i-Noor Magic FX pencils.

Special Effects Lettering and Calligraphy

Rainbow pencils are sold sharpened to a fine point. If you want to get the full multicolored effect straight away, here's what you can do.

1.

Scratch the pencil on paper until the tip is flattened. This gives you a better chance of getting all the color combinations possible when you start creating your artwork.

2.

Draw a few lines and get the feel of the pencil by holding it a little more upright than you usually would and making sure that the tip is lying flat on the paper.

3.

You can also use the pointier edge to create a finer line. The lead is soft enough that you can achieve thick and thin line variations, depending on how much pressure you put on the pencil.

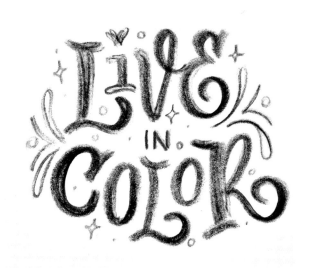

↑ Two lettering pieces I created using rainbow pencils. *(Right)* French: Where there's a will, there's a way

BRUSH PENS

It's easy to see why brush pens are very popular when it comes to writing in script modern calligraphy. They're fun, convenient, come in an array of different colors, and are affordable. My favorites are the Karin Brushmarker PRO Markers. The tips are sturdy and don't fray.

Here's how you can take full advantage of these versatile pens.

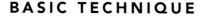

BASIC TECHNIQUE

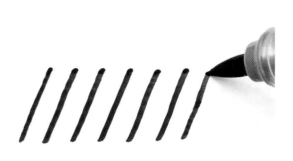

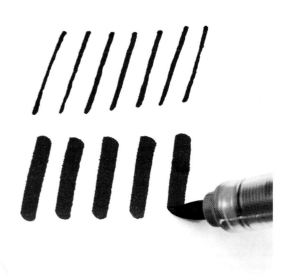

1.

Try making thin upstrokes. Start from the bottom with your pen and draw lines in an upward motion. Keep the pen pressure as light as possible to achieve thin strokes.

2.

Now, try the opposite approach. Start at the top and draw lines in a downward motion, but this time, make sure to use as much pressure as possible to achieve thick strokes.

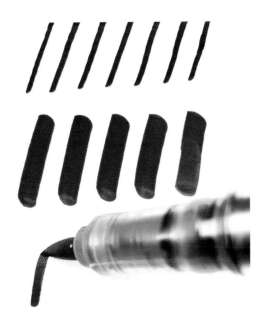

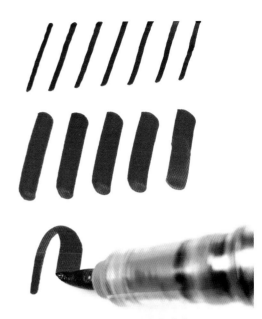

3.

Draw a curve that transitions from a thin to a thick stroke. Start drawing upward, making sure to use as little pressure as possible.

4.

When you're almost at the top of the curve, slowly start adding heavier pressure on the letter stroke so that it transitions from thin to thick.

Leren
doe je met
vallen
en
opstaan

↑ Dutch: You learn by trial and error

Let's use this technique to draw the lowercase letter *h*.

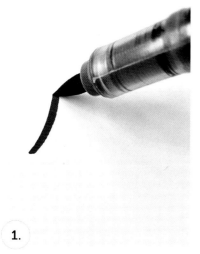

1.

Start with a thin line for your next upstroke.

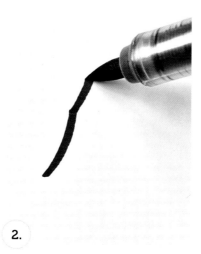

2.

Transition from a thin stroke to a thick stroke on the loop of the *h*.

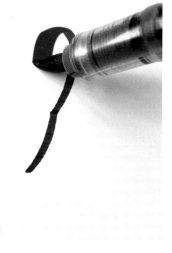

3.

Make another curve that transitions from a thin stroke to a thick stroke.

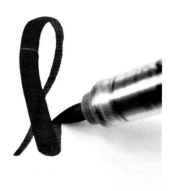

4a.

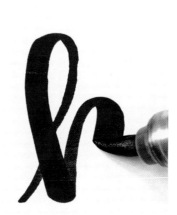

4b.

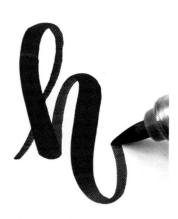

4c.

The last curve transitions again from a thick stroke to a thin stroke.

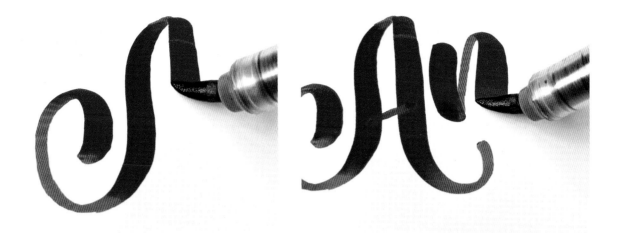

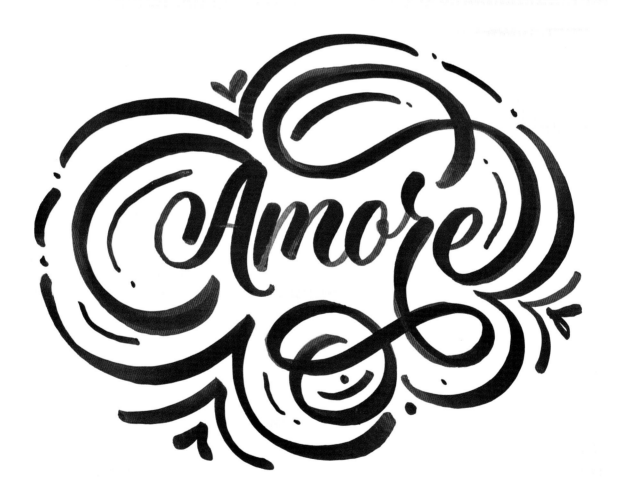

⬆ A lettering sample with the word *Amore*.

METALLIC WATERCOLOR PAINTS

These magical paints create special effects all on their own. The ones I like to use are from an independent shop called Reneeissance Colours. They offer a variety of paints and inks, including colorshift pans that change color depending on the light, glittery iridescent pans, and shiny metallic pans.

A paintbrush, some water, and watercolor paper are all you need to use these colorful pans.

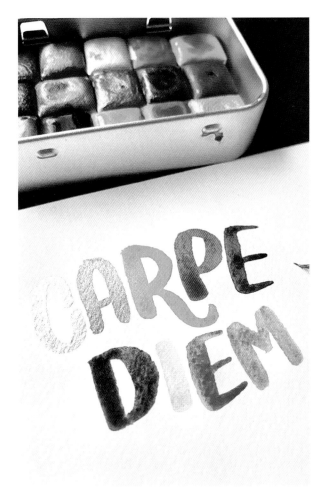

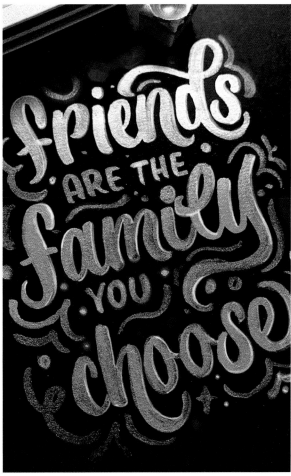

✝ Latin: Seize the day

One of the great things about the glass pen is how convenient it is to use. Usually, when you put ink in a pen, you have to wait until it's all used up to change to a different color. The glass pen works just like a paintbrush. Just dip the tip of the glass pen in the bottled ink and start writing. I use fountain pen ink from Ferris Wheel Press and a Kunisaki Glass Dip Pen from Wancherpen International.

 Just as with the gel pen (see page 16), I used coated paper so it's easier to see the intensity of the ink color.

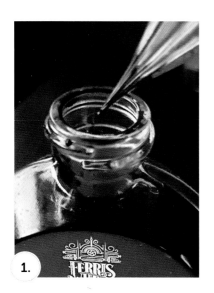

1.

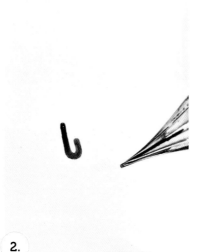

2.

3.

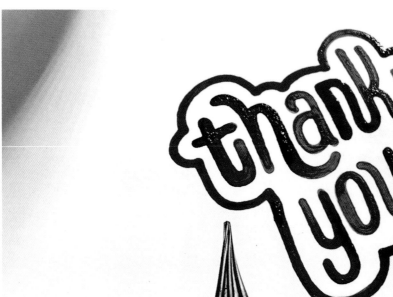

PAPER

When it comes to paper, I use three different types: watercolor paper, dot grid paper, and coated paper.

- ✳ I use watercolor paper when I am writing or doodling with paints and ink.

- ✳ I use dot grid, or dotted, paper for everyday writing and as a practice pad. Using the dots as a guideline is very helpful when it comes to doing drills and making drafts.

- ✳ I use the coated paper to experiment and to show different pen effects.

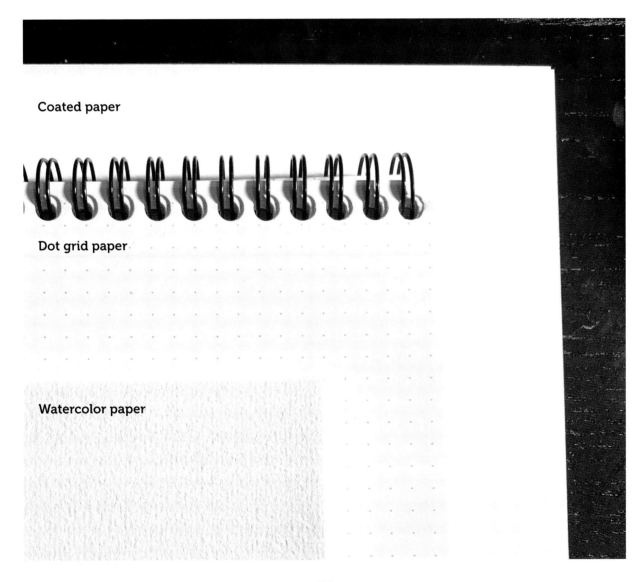

Coated paper

Dot grid paper

Watercolor paper

2

CREATIVE LETTERING FOR BEGINNERS

I've always thought of hand lettering as the most welcoming of art forms. It's a gateway that brings the written word into the world of design.

When I first started exploring the art of letters, I was amazed by all the things you could do with the shapes and lines that we've been taught as children. Who knew there were a million and one ways to write the letter *A*?

In this chapter, we explore the basics of lettering, which will give us the groundwork to discover the many ways we can have fun with letterforms. It will also eventually help us learn how to find and develop our own unique style, possibly even finding a million more ways to write the letter *A*.

HAND-LETTERING BASICS

Everyone has their own style of handwriting. It's something that we've been taught since we were children. But is it the same as hand lettering? Do you need to have good handwriting to be a good lettering artist? These are some of the initial questions that get asked a lot by beginners who aren't sure about jumping into the deep end of the lettering pool.

HANDWRITING VS. LETTERING

Basically, handwriting focuses on writing letters, while lettering focuses on designing and drawing letters. Having pretty or "perfect" handwriting isn't required to be good at hand lettering because each employs a different type of skill.

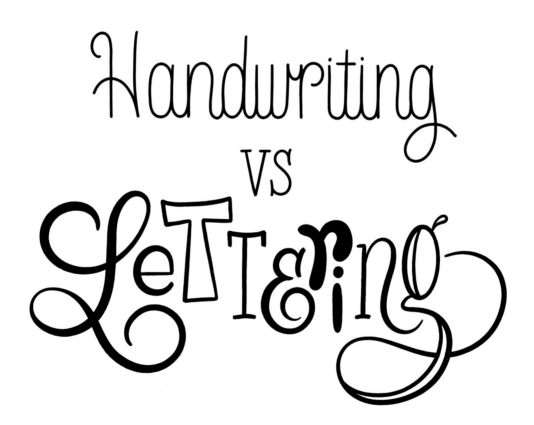

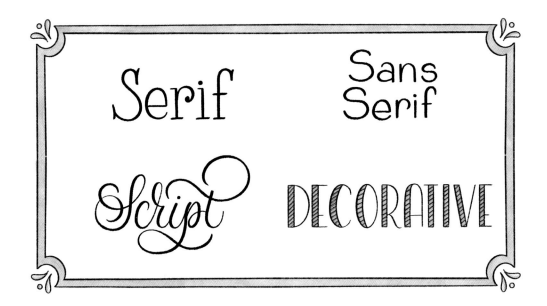

TYPES OF LETTERING STYLES

You're probably already familiar with hand lettering because it's a style of lettering that's seen everywhere: in computer fonts, signages, logos, books, food labels, and loads of other stuff.

There are four basic types of hand lettering. Here's a short introduction and explanation of each type:

* **Serif.** These letters have short, distinguishable lines that are part of the main letter strokes. This style of lettering is usually used to convey a more traditional and classic look and evokes images of writing on a typewriter.

* **Sans Serif.** The main characteristic of this lettering style is the absence of the short lines that are in the serif letters. The sans serif style is usually used for a more modern and clean look.

* **Script.** This type of lettering is the closest to handwriting. The linking of the letters is the main characteristic of the script lettering style. As with most calligraphic styles, it's used to convey elegance and sophistication.

* **Decorative.** This type of lettering is a catchall that includes all the experimental lettering styles that have more fun and relaxed characteristics.

There are various subgroups and categories, but in this book, these four main groups are the ones we'll have fun with.

31

LETTERING STYLES

Let's take a closer look at each of these styles using examples of hand-lettered alphabets that you can try out on your own.

SANS SERIF

The sans serif alphabet is the easiest style to write. It's a good place to start because it consists of the basic letter strokes that we all learned to use when we first started learning to write as children, before we were taught to link letters and write in cursive. Even though it looks deceptively simple, practicing it gives you a good foundation and helps with making consistent letter strokes.

Use the simple print alphabet below as a warm-up. Follow the numbered guides and arrow directions. Your favorite everyday, monoline pen will work well for this style, as long as it produces a consistent line weight regardless of the pressure applied.

◼ SANS SERIF: BASIC PRINT STYLE

Aa Bb Cc Dd Ee

Ff Gg Hh Ii Jj Kk

Ll Mm Nn Oo Pp

Qq Rr Ss Tt Uu

Vv Ww Xx Yy Zz

! ?

Aa Bb Cc Dd Ee

Ff Gg Hh Ii Jj Kk

Ll Mm Nn Oo Pp

Qq Rr Ss Tt Uu

Vv Ww Xx Yy Zz

! ?

There are small things you can do to subtly change the style and characteristics of your letters. Follow the examples below and experiment with your letter strokes.

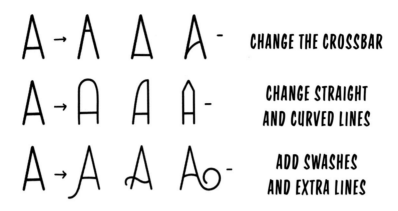

SANS SERIF: BASIC PRINT STYLE, VARIATION

Here's a style variation derived from the previous alphabet. I added small flourishes (swashes), curves, and tiny details to give it a bit more character. Give it a try and see what you come up with!

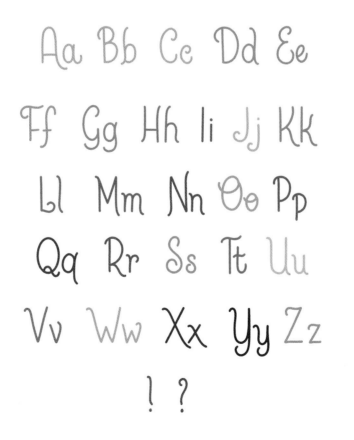

Special Effects Lettering and Calligraphy

Aa Bb Cc Dd Ee

Tf Gg Hh Ii Jj Kk

Ll Mm Nn Oo Pp

Qq Rr Ss Tt Uu

Vv Ww Xx Yy Zz

! ?

Here are a few examples using a combination of the two alphabet styles. Even when you start with the simplest of strokes, you can already see the beginnings of a fun, modern style.

Time spent
together
is time
well spent

Mangia bene,
ridi spesso,
ama molto

↑ Italian: Eat well, laugh often, love a lot

Special Effects Lettering and Calligraphy

À cœur vaillant, rien d'impossible

↑ French: With a valiant heart, nothing is impossible

Leagfaidh tua bheag crann mór

↑ Irish: A small axe can fell a big tree

■ SANS SERIF: BRUSH PRINT STYLE

Although brush pens are more commonly used in script and calligraphy, I like dusting them off for print-style lettering because they add a fun, offbeat quality to the letter strokes. Use the same alphabet you created previously, but this time, add line variations with the brush pens.

Aa Bb Cc Dd Ee

Ff Gg Hh Ii Jj Kk

Ll Mm Nn Oo Pp

Qq Rr Ss Tt Uu

Vv Ww Xx Yy Zz

! ?

Special Effects Lettering and Calligraphy

Aa Bb Cc Dd Ee

Ff Gg Hh Ii Jj Kk

Ll Mm Nn Oo Pp

Qq Rr Ss Tt Uu

Vv Ww Xx Yy Zz

! ?

Brush Pen Warm-ups Revisited
(Plus Some New Ones)

• • •

In the previous chapter, I demonstrate how to use brush pens (see page 20). Remember to press down hard on the pen tip to create thick lines when making downstrokes. Then, slowly ease up on the pressure when transitioning to the upper strokes. Review the following warm-up brush pen strokes and practice the exercises before trying out this alphabet style.

‖‖‖‖‖‖ –	**STRAIGHT LINE DOWNSTROKES**
⫽⫽⫽⫽⫽ –	**SLANTED DOWNSTROKES**
↑‖‖‖‖‖ –	**STRAIGHT LINE UPSTROKES**
↗⫽⫽⫽⫽ –	**SLANTED UPSTROKES**

Special Effects Lettering and Calligraphy

∩ ∩ ∩ ∩ ∩ – **OVERTURNS**

υ υ υ υ υ – **UNDERTURNS**

ᘉ ᘉ ᘉ ᘉ ᘉ – **COMPOUND CURVES**

ᘎ ᘎ ᘎ ᘎ ᘎ – **REVERSE COMPOUND CURVES**

Ο Ο Ο Ο Ο – **OVALS**

ᗰᗰᗰᗰᗰᗰᗰ – **ZIGZAGS**

ⅇⅇⅇⅇⅇⅇⅇ – **SPIRALS**

SANS SERIF: BRUSH PRINT STYLE, VARIATION

It's fun to create a different alphabet style just by experimenting. For this alphabet, I changed the size and shape of the letter strokes. I deliberately drew some letters crooked, irregular, and uneven. This is an enjoyable exercise that also helps you see the letters from a different perspective, which is refreshing, especially when following the rules starts feeling restrictive.

Aa Bb Cc Dd Ee

Ff Gg Hh Ii Jj Kk

Ll Mm Nn Oo Pp

Qq Rr Ss Tt Uu

Vv Ww Xx Yy Zz

! ?

Aa Bb Cc Dd Ee

Ff Gg Hh Ii Jj Kk

Ll Mm Nn Oo Pp

Qq Rr Ss Tt Uu

Vv Ww Xx Yy Zz

! ?

Grab your brush pens and start experimenting with those letter shapes!

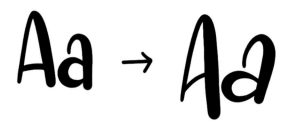

Combine the sans serif brush lettering alphabet plus the variation alphabet you created and write down your favorite phrase.

Go a bit further. Add some curved lines to the side of your quote and create a frame around it. You can also add embellishments and little doodles to fill in the spaces in between.

Audentes Fortuna Iuvat

↑ Latin: Fortune favors the brave

↑ Spanish: Love can do everything

Serif styles include little lines and dashes at the end points of letter strokes. This lettering style always reminds me of a typewriter. It's traditional and formal, but it can also have a hidden fun side to it, especially when you start experimenting with different ways to add those little serif lines. Take your sans serif alphabet and add dashes and lines to transform it into a serif alphabet.

▦ SERIF: TALL PRINT STYLE

Aa Bb Cc Dd Ee

Ff Gg Hh Ii Jj Kk

Ll Mm Nn Oo Pp

Qq Rr Ss Tt Uu

Vv Ww Xx Yy Zz

! ?

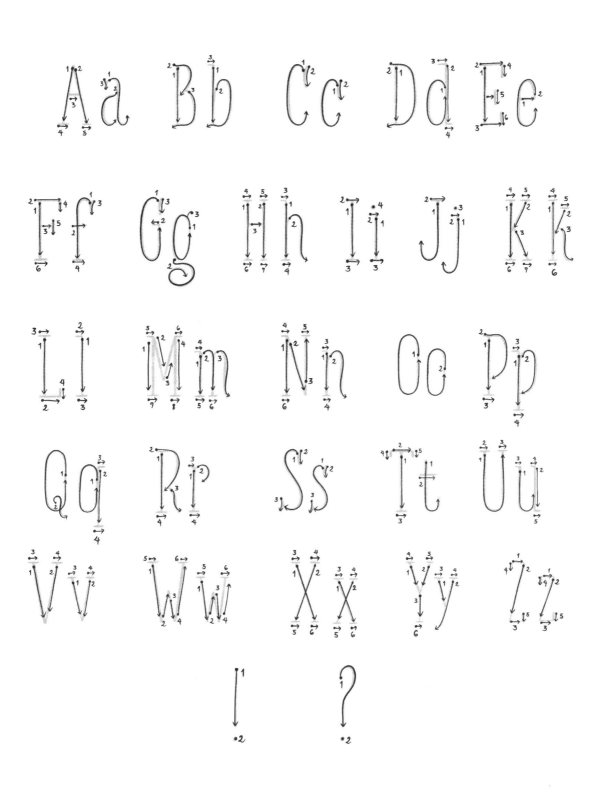

CREATIVE LETTERING FOR BEGINNERS

■ SERIF: TALL PRINT STYLE, FLOURISHED VARIATION

The serif style can look a little rigid, so for variety, I like to add elegant flourishes. I'll discuss how to create flourishes more carefully in the next chapter (see Flourishing on page 78). Begin to get familiar with flourishes by following the arrow and line directions in the guide below.

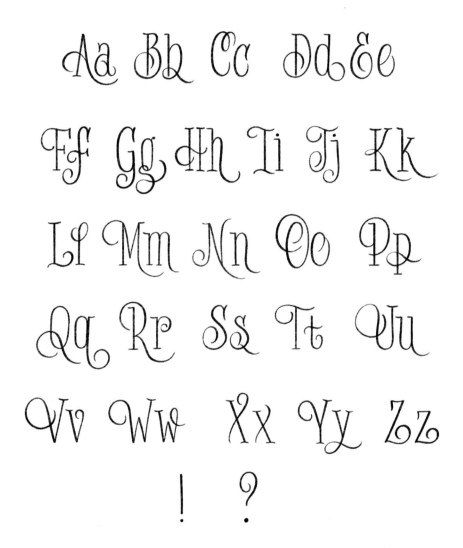

Special Effects Lettering and Calligraphy

Aa Bb Cc Dd Ee

Ff Gg Hh Ii Jj Kk

Ll Mm Nn Oo Pp

Qq Rr Ss Tt Uu

Vv Ww Xx Yy Zz

I ?

49

Combine both styles to create a beautiful lettering piece. I prefer using a brush pen with this style to add line variation. But this alphabet also works with just your regular monoline pen.

Ar scáth
a chéile
a mhaireann
na daoine

↑ Irish: People live in each other's shadows

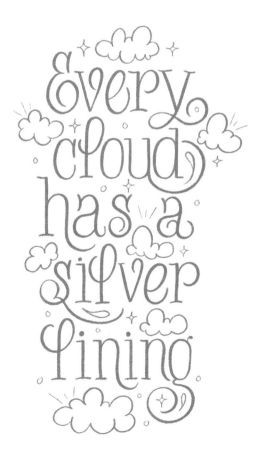

Special Effects Lettering and Calligraphy

Ei kukaan
ole seppä
syntyessään

⬆ Finnish: No one is born a smith

Kaya
mo
yan

⬆ Tagalog: You can do it

■ SERIF: CURVY PRINT STYLE WITH SPLIT SERIFS

Another way to create a serif-style alphabet is to add curved lines and split serif lines like in the style below. My inspiration for this is the design of kitchen tiles. Try it out for yourself and follow the letter guides.

Aa Bb Cc Dd Ee

Ff Gg Hh Ii Jj Kk

Ll Mm Nn Oo Pp

Qq Rr Ss Tt Uu

Vv Ww Xx Yy Zz

! ?

SERIF: CURVY PRINT STYLE WITH SPLIT SERIFS, EMBELLISHED VARIATION

Transform this alphabet by adding some simple embellishments within the spaces in the letters. You can add something extra by using different colors for each letter. This style can be used for fun monograms as well. Go a little further and add simple illustrations to your lettering pieces.

Aa Bb Cc Dd Ee

Ff Gg Hh Ii Jj Kk

Ll Mm Nn Oo Pp

Qq Rr Ss Tt Uu

Vv Ww Xx Yy Zz

! ?

Special Effects Lettering and Calligraphy

To imagine is to choose

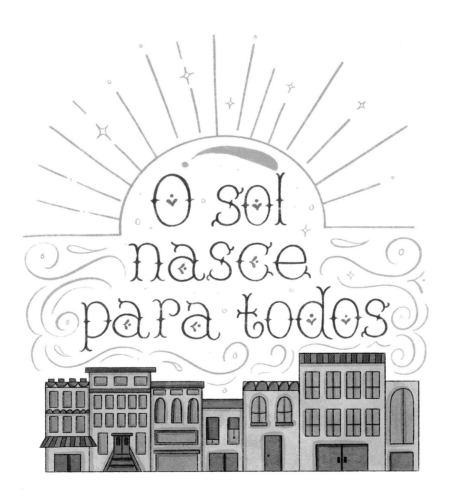

O sol nasce para todos

↑ Portuguese: The sun rises for everyone

CREATIVE LETTERING FOR BEGINNERS

This lettering type is the closest to cursive writing and is a very popular choice when creating signages for special occasions or for addressing envelopes and greeting cards.

■ SCRIPT: MONOLINE STYLE

For this style, use a monoline pen to create neat and legible letter strokes. Each letter has minimal flourishes, just enough to give them an elegant look. Try out this style and use the letter guide on the opposite page.

Aa Bb Cc Dd Ee

Ff Gg Hh Ii Jj Kk

Ll Mm Nn Oo Pp

Qq Rr Ss Tt Uu

Vv Ww Xx Yy Zz

! ?

Aa Bb Cc Dd Ee

Ff Gg Hh Ii Jj Kk

Ll Mm Nn Oo Pp

Qq Rr Ss Tt Uu

Vv Ww Xx Yy Zz

! ?

SCRIPT: MONOLINE STYLE, FLOURISHED VARIATION

Create a variation of this alphabet by changing the orientation of the letter. Experiment by adding extra flourishes.

Aa → Aa

Aa Bb Cc Dd Ee
Ff Gg Hh Ii Jj Kk
Ll Mm Nn Oo Pp
Qq Rr Ss Tt Uu
Vv Ww Xx Yy Zz
! ?

Combine the two styles to create a beautiful lettering piece. Go a bit further and add big flourishes.

Patience is a Virtue

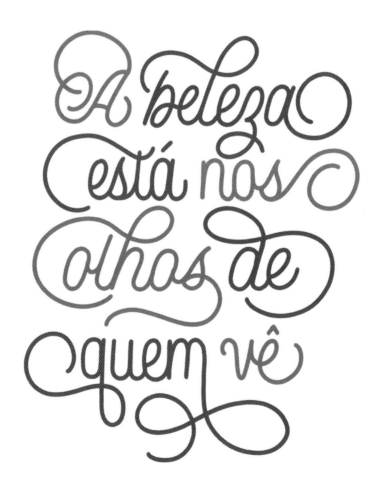

Portuguese: Beauty is in the eyes of the beholder

Special Effects Lettering and Calligraphy

Ingen roser uden torne

↑ Danish: There is no rose without a thorn

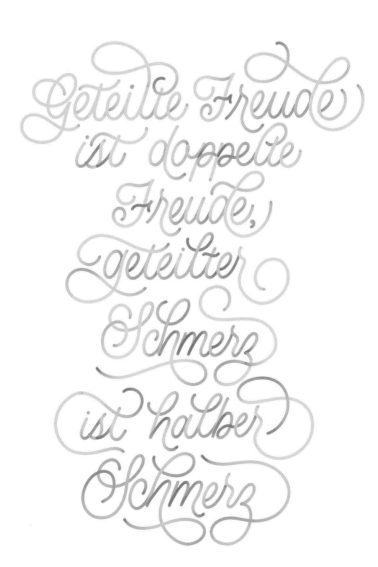

Geteilte Freude ist doppelte Freude, geteilter Schmerz ist halber Schmerz

↑ German: Joy shared is joy doubled, pain shared is pain halved

For this style, use a brush pen to achieve line variation in your letter strokes. While the first alphabet style was focused on legibility, this style is more focused on the calligraphic nature of script letters.

■ BRUSH SCRIPT: BASIC SCRIPT

Aa Bb Cc Dd Ee
Ff Gg Hh Ii Jj Kk
Ll Mm Nn Oo Pp
Qq Rr Ss Tt Uu
Vv Ww Xx Yy Zz
! ?

Aa Bb Cc Dd Ee

Ff Gg Hh Ii Jj Kk

Ll Mm Nn Oo Pp

Qq Rr Ss Tt Uu

Vv Ww Xx Yy Zz

! ?

Add extra details by drawing curls and flourishes.

Aa → Aa

Aa Bb Cc Dd Ee

Ff Gg Hh Ii Jj

Kk Ll Mm Nn Oo Pp

Qq Rr Ss Tt Uu

Vv Ww Xx Yy Zz

! ?

Aa Bb Cc Dd Ee

Ff Gg Hh Ii Jj

Kk Ll Mm Nn Oo Pp

Qq Rr Ss Tt Uu

Vv Ww Xx Yy Zz

! ?

Here are some lettering examples that combine both script styles.

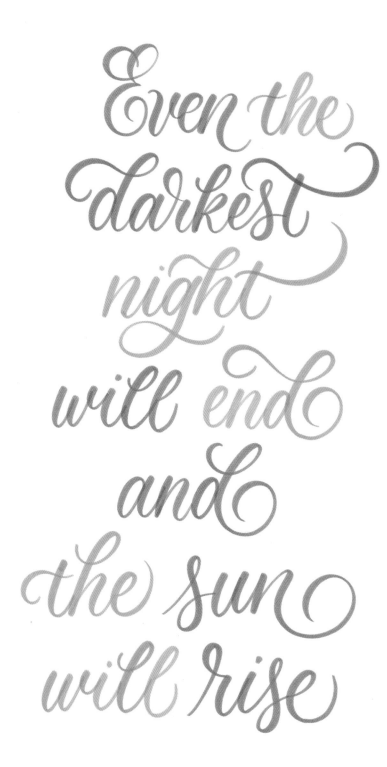

Even the darkest night will end and the sun will rise

⬆ Quote by Victor Hugo, author of *Les Misérables*.

Special Effects Lettering and Calligraphy

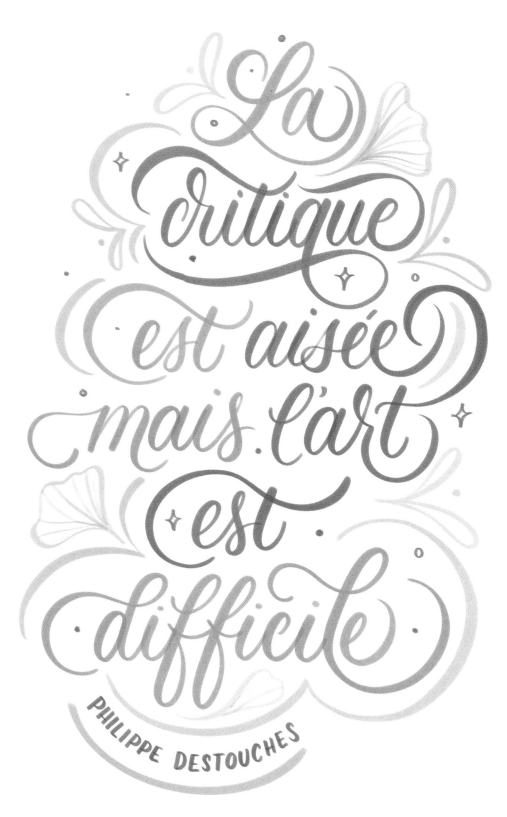

La critique est aisée mais l'art est difficile

PHILIPPE DESTOUCHES

French: Criticism is easy, but art is difficult

Decorative alphabets are my favorite type of lettering because its informality provides a lot of freedom to create and pushes me to come up with fun ideas for letterforms.

ICED GINGERBREAD

This style came from combining bubble letters and my love for gingerbread houses. The brown, blobby shapes represent the cookie base, and the white accents are the sugar icing. It's also a fun activity you can do with your little artists at home that doesn't require use of an actual oven! You can even use it to plan out cookie designs.

To make the letters, I used a brown Copic Ciao Alcohol Marker. These markers are good for coloring backgrounds because they provide an even base and leave very few streaks compared to water-based markers.

For the white accents, I used a Sakura Gelly Roll white gel pen. Be careful when choosing your white pen—not all brands react well on darker backgrounds. If you can't find a white gel pen you like, paint pens, or paint markers, are a good alternative.

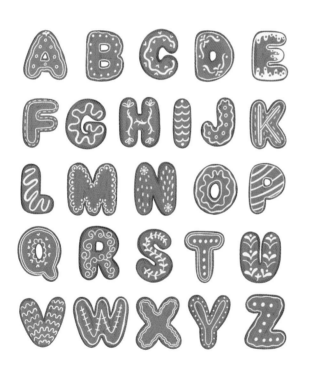

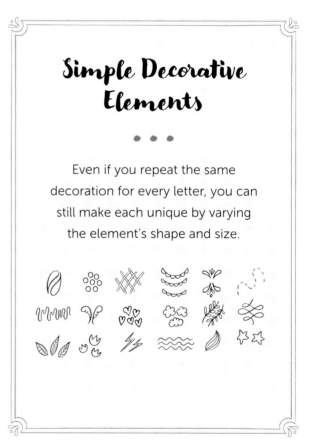

Simple Decorative Elements

• • •

Even if you repeat the same decoration for every letter, you can still make each unique by varying the element's shape and size.

1.

Start by outlining your bubble letters. For this alphabet, consistency isn't as important as in other letterforms because they're supposed to imitate the imperfect shapes of freshly baked cookies. I usually recommend drafting letters in pencil, but not in this case, because the pencil marks will be visible even after the marker is applied.

2.

Fill in the outlines, making sure to leave enough room for the spaces between the letters.

3.

If you want to achieve a toasted cookie effect, go over some areas a few more times with the marker.

4.

Now comes the fun part, decorating with the white gel pen. There are a lot of different doodle elements, patterns, and shapes you can apply. This style is very forgiving and mistakes aren't immediately noticeable, so this is a good opportunity to experiment. You can also look at images of iced gingerbread and try to re-create their decorations.

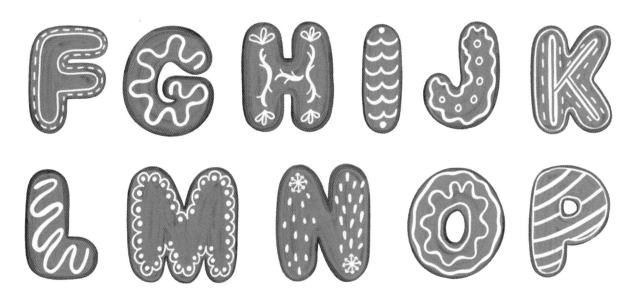

A closer look at the icing details on the letters.

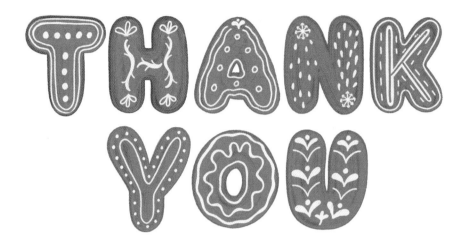

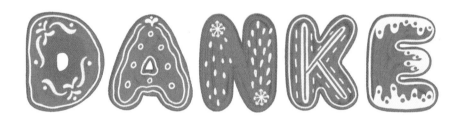

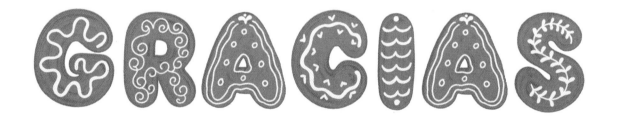

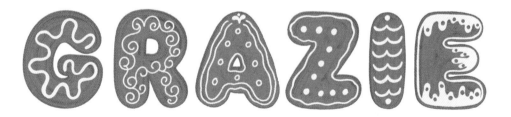

The expression *thank you* in English, German, Spanish, and Italian.

Special Effects Lettering and Calligraphy

■ THEMED DECORATIVE LETTERING

There are many other ways to use bubble letters. Think of different words and use them as prompts for visual themes to illustrate various words and phrases. Here are other ones that I've made.

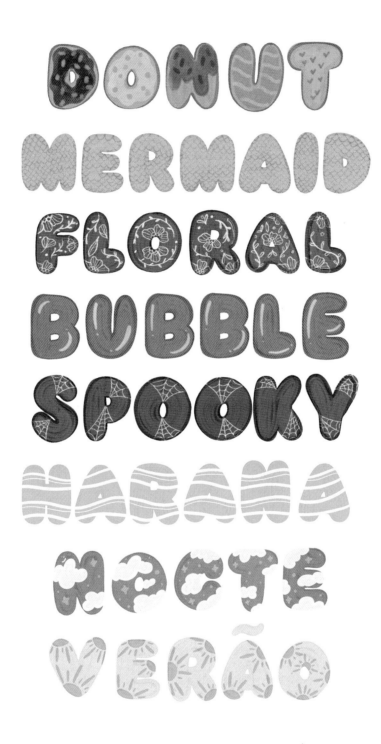

71

■ FUNFAIR DECORATIVE ALPHABET

This fun lettering design evokes the display typefaces used in the United States during the nineteenth century, especially in the American West, and on theatrical and circus posters.

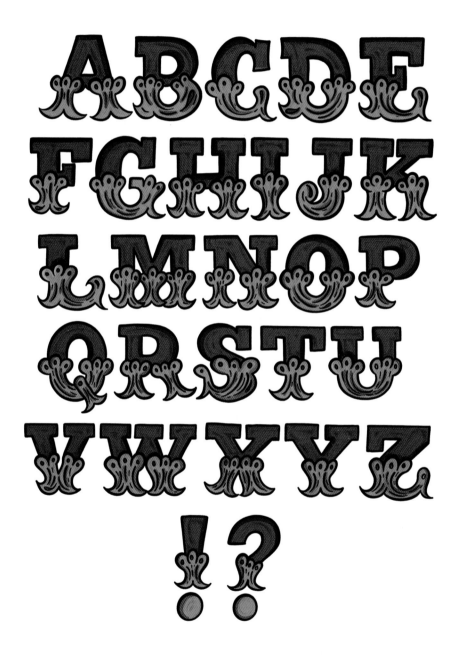

Special Effects Lettering and Calligraphy

1.

Write the letters out normally.

2.

Outline your serif letters.

3.

Create a fun design by drawing ornamental doodles in the lower half of the letterform.

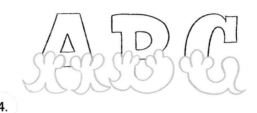

4.

Erase any extra lines that interfere with the doodled design.

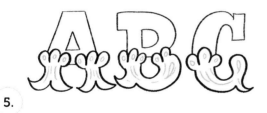

5.

Add extra details and flourishes.

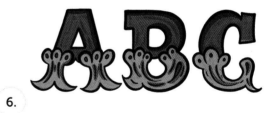

6.

Color in the letters using two different colors for the upper and lower halves.

CREATIVE LETTERING FOR BEGINNERS

HELLO
CIAO
HOLA
BONJOUR

↑ The word *hello* in English, Italian, Spanish, and French.

Special Effects Lettering and Calligraphy

FUNFAIR, EMBELLISHED VARIATION

Go a bit further and create your own decorative style by adding doodles, layering embellishments, and visualizing a theme.

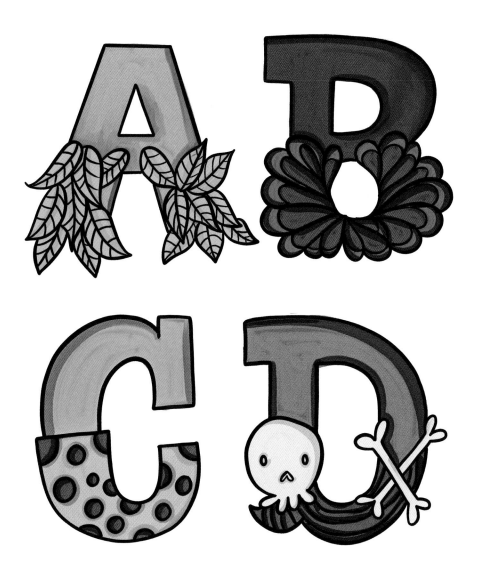

CREATIVE LETTERING FOR BEGINNERS

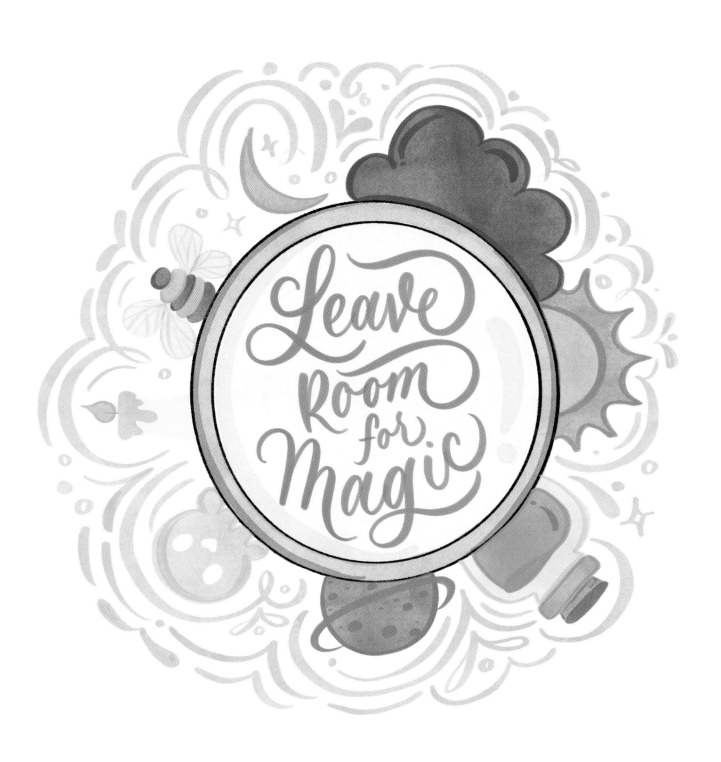

· 3 ·

ADDING EXTRA SPARKLE

Now that you know how to create different lettering styles, there are a few things you can do to elevate your letter-forms even further. You can draw attention to them by adding certain extra elements.

Flourishes, also called swashes, are embellishments that you can add to your letters to make them stand out. They can take your hand-lettered pieces from plain to extravagant just by adding a few curls and loops. But where do you start? Knowing where to flourish can sometimes be confusing because you don't want to make your words look overcrowded or illegible. In addition to looking elegant, they still need to be readable and look balanced.

In the example below, I've written the word *beautiful* in a normal script. Then, I extended the ascender (upward) and descender (downward) loops by adding curls and making the space in between them bigger. This creates an effect that makes the word bigger, important, and eye-catching.

If you're just starting out with flourishing, be sure to draft your words first using a pencil and an eraser. Once you get more used to it, you'll be able to flourish as you go.

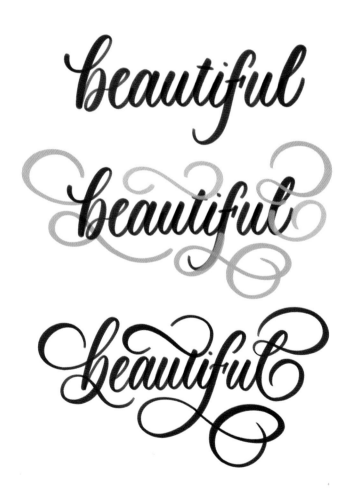

So where *exactly* in the word do you flourish?

That is usually the first question asked when you're faced with a word you just wrote that needs an extra bit of flair. Flourishing can look random and natural, but it takes a bit of planning to make it look that way.

The most common way to flourish is on the top or the bottom of the word. It's easy to find opportunities to do that by paying close attention to the following letters.

First, look for upper loops in letters, also known as *ascender loops*. The letters *b, d, h, k, l,* and *t* have loops on top that you can play around and experiment with. Here are some examples of how you can flourish those ascender loops.

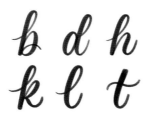
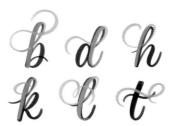

The next most common location to flourish is at the bottom of the letter, also known as *descender loops*. The letters *f, g, j, p, q, y,* and *z* have loops at the bottom that you can extend and add extra curls to.

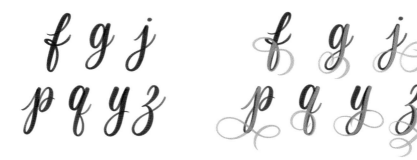

Why not try it out for yourself? Write your script letters as you normally would and experiment with the flourishes in both the ascender and descender loops.

You can also find other places to flourish, even on letters that don't have a natural loop of their own. In the example below, I added some on top of the lowercase *a*. Think of the *at sign* (@) symbol and make the letter strokes more elegant around it.

Another way to flourish is by extending the normal letter strokes and adding loops to them. In the example of the lowercase *m* below, you'll see that I extended the middle stroke. This adds a fun, unique element to the letter. Although the lowercase *m* doesn't have a natural loop of its own, you can add one to it as long as there's space at the bottom.

In the third example, I used the crossbar (horizontal stroke) of the lowercase *t* to connect to the next letter. Instead of the usual way of crossing the *t* with a straight line, I extended it by drawing a curve.

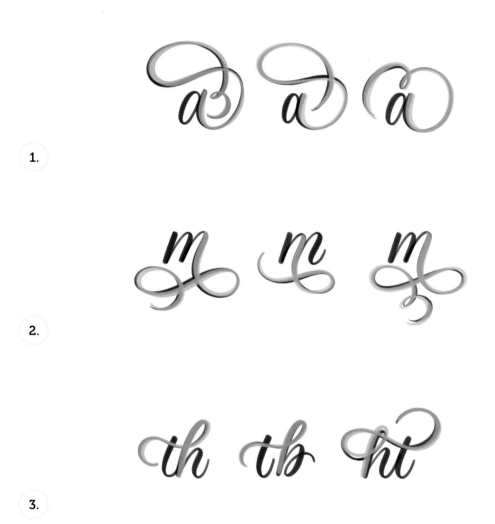

1.

2.

3.

In the example below, you can see where I added flourishes to the word *Thursday*.

thursday → Thursday

1.

A flourish is added to the crossbar of the *t* at the beginning of the word.

thursday → thursday

2.

A flourish is added to the lowercase *r* in the middle of the word, adding the loops directly at the bottom of the letter.

thursday → thursday

3.

A flourish is added to the lowercase *d* using the ascending loop as a way to extend the flourish.

thursday → thursday

4.

A flourish is added to the lowercase *y* at the end of the word.

thursday → thursday

5.

A flourish is added to the crossbar of the *t*, connecting it to the ascending loop of the lowercase *h*.

thursday → thursday

6.

A flourish is added to a variety of places by combining different elements to make it look graceful and balanced.

Here are a few more flourishing examples of hand-lettered names. Notice that each of the words has a beginning and an ending flourish that can also extend to the middle. When there's room for it, a separate middle flourish will make the word look more balanced.

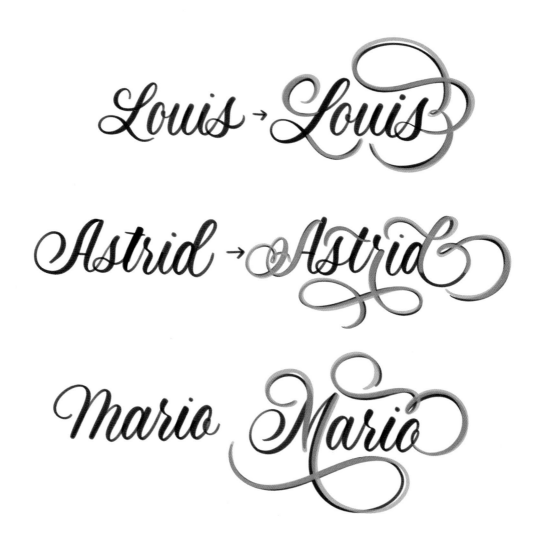

Special Effects Lettering and Calligraphy

Here are a few more examples that take normal script to flourished phrases.

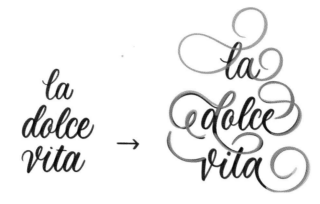

↑ Italian: The sweet life

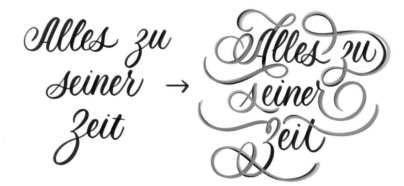

↑ German: Everything in its own time

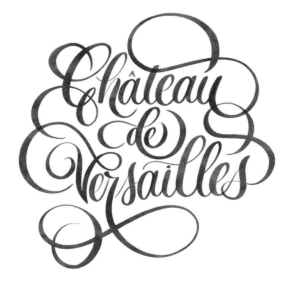

↑ French: Palace of Versailles

ADDING EXTRA SPARKLE

FAUX CALLIGRAPHY

Faux calligraphy is a quick and easy technique to create contrasting thick and thin lines, which you can usually only do with the flexible tip of a pen. It's a great introduction for lettering beginners who want to get familiar with the letterforms, but might find brush pens a little intimidating to use.

This technique also gives you even more opportunities to be creative by adding patterns and colors inside the hollowed-out downstrokes.

Line variation is one way to make your letters stand out. You can create that effect using a brush pen by making bold lines on the downstrokes of your letters. If you don't want to use a brush pen, there's also a way to achieve the same effect by adding the lines in using a regular, monoline pen. You can then fill in the hollow blocks you drew.

Not filling it in and keeping the blocks hollow offers another distinct appearance as well. Instead, you can add a pattern or fill it in with another color that's different from the outline.

This is one of the easiest ways to add special effects to your lettering.

INCREDIBLE DELIGHTFUL

generous powerful

INCREDIBLE DELIGHTFUL

generous powerful

INCREDIBLE DELIGHTFUL

generous powerful

Special Effects Lettering and Calligraphy

You can see the full effect of it when combining it with different letter styles. In the example below, you can see how it looks next to a flourished script word.

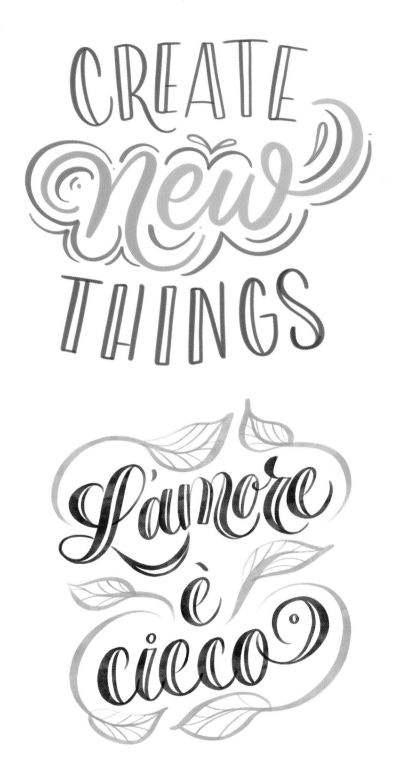

↑ Italian: Love is blind

Adding shadows brings a new dimension to your lettering. It almost looks like it could pop out of your page. The trick to creating good and accurate shadows is to first think of your light source. Which side is the light shining on? In the example below, the light is coming from the left side of the word *serendipity*. This means that the shadows need to be added on the right side of the letter strokes. Make sure you're consistent and stay on the correct side all throughout the word.

Here are three ways that you can enhance playing with shadow letters.

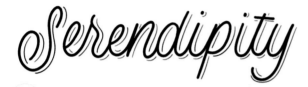

Add small lines next to the letters to create highlights.

1.

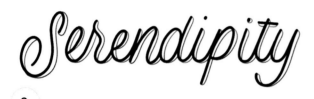

Extend the small lines and create an outline on the side of the letters. You can also fill it in with a different color to create a fun effect.

2.

Add shadows using a lighter color than that of the base word.

3.

↑ Practice your special effects skills and attempt to create shadows using the light source on the right. Experiment with the highlights, outline, and shadow effects.

Special Effects Lettering and Calligraphy

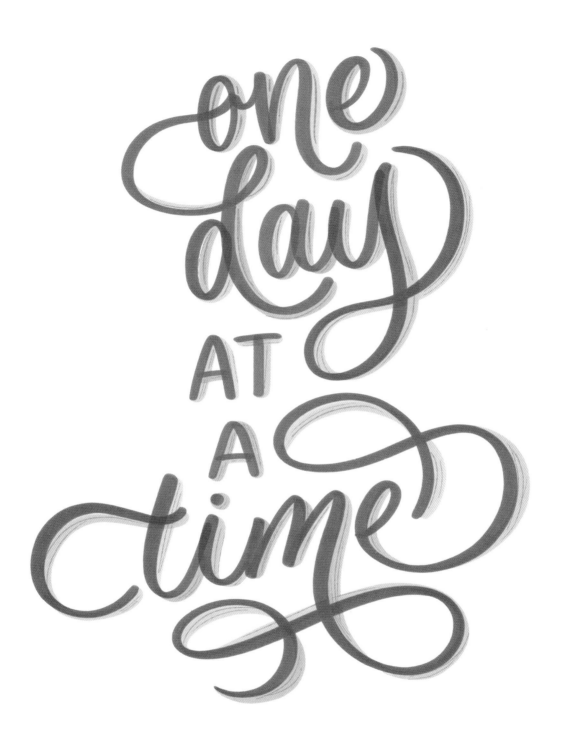

↑ A sample lettering piece.

ADDING EXTRA SPARKLE

RIBBON LETTERING

Creating a ribbon effect with your lettering is a fun way to make your artwork pop out of the page. It creates an almost 3D illusion to your words. One of the easiest ways to do this is by using three different shades of the same color.

1. Use the lightest shade to draw a curvy line that resembles a ribbon.

2. With a pencil, mark the edges where you want your ribbon to fold and overlap.

3. Use the next shade to color in the marked areas.

4. Use the darkest shade to color in the edges to create more depth.

5. Blend the dark and light shades and add some highlights to the outside of the ribbon.

Special Effects Lettering and Calligraphy

Try it out yourself with a word of your choice.

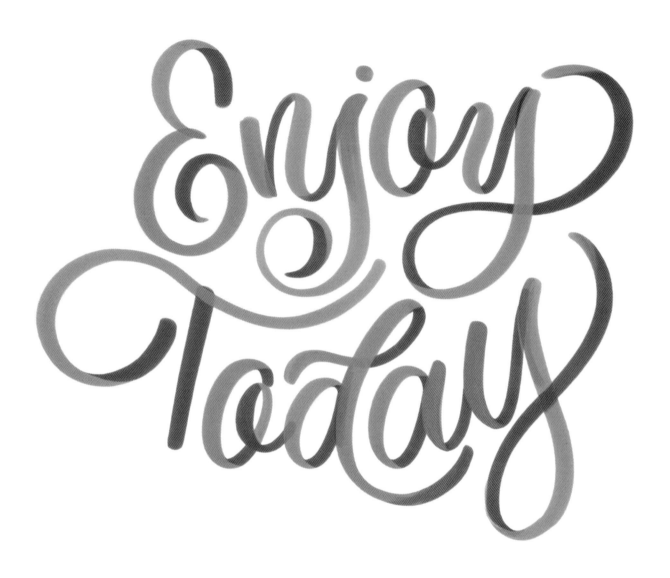

A lettering piece with the ribbon effect.

NEGATIVE SPACE LETTERING

Playing with space is another great way to add special effects to your lettering. Basically, this means that instead of drawing the letters, you draw the space around them. This creates a cool effect that highlights the embellishments you've chosen, but at the same time, it also shows the word. It's like writing out the word by *not* writing it.

1.

Draft out your word with a pencil. Using bubble letters is a good way to showcase the embellishments we will add later.

2.

Think of the embellishments and design elements you want to use and start adding them around the letters.

3.

Continue to do this around the word, making sure that you haven't left any blank spaces. It's important to leave a mark in all the corners and crevices so that the word will pop out.

4.

Add some highlights to the embellishments.

5.

Erase the pencil lines and make sure that the word is legible.

↑ Spanish: Peace

ADDING EXTRA SPARKLE

Creating the illusion of a peeled sticker is another cool way to showcase your lettering. It's a step beyond adding a frame and embellishments to your letters because you combine it with a 3D effect. Here's an easy way to create it.

1. Draw the shape of your sticker with a pencil. I drew a rectangle.

2. Decide where you want the sticker to peel. Two facing corners works really well for this shape. Mark them with broken lines.

3. Draw the peeling edges inward on the opposite sides of the broken lines.

4. Erase the original outer lines at the two edges, removing the corners so only the folded pieces are left.

5. Finish your design and color in the sticker. Use shading to add depth and dimension to the peeled edges.

Below are some examples of peeled sticker lettering. Try them out for yourself and experiment with different shapes.

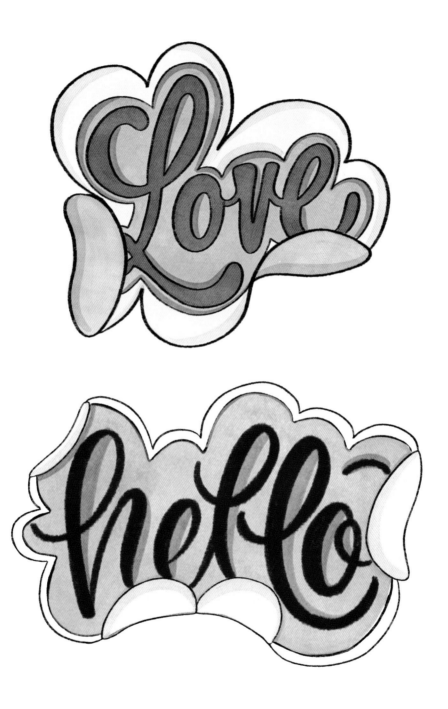

ADDING EXTRA SPARKLE

Making 3D letters can look intimidating, but there's a simple step-by-step way to create them.

1. First, draw the outline of your letters. Just like in the negative space lettering effect, hollow letters with edges work best.

2. Next, draw short diagonal lines on the edges of the letters.

3. Connect the diagonal lines with each other.

4. Add the inner shadows using the same method.

5. Color in your letters.

Here's an example of a lettering piece with the 3D effect combined with an overlapping ribbon across the letters. Experiment with this lettering on your own and see what creative combinations you can come up with!

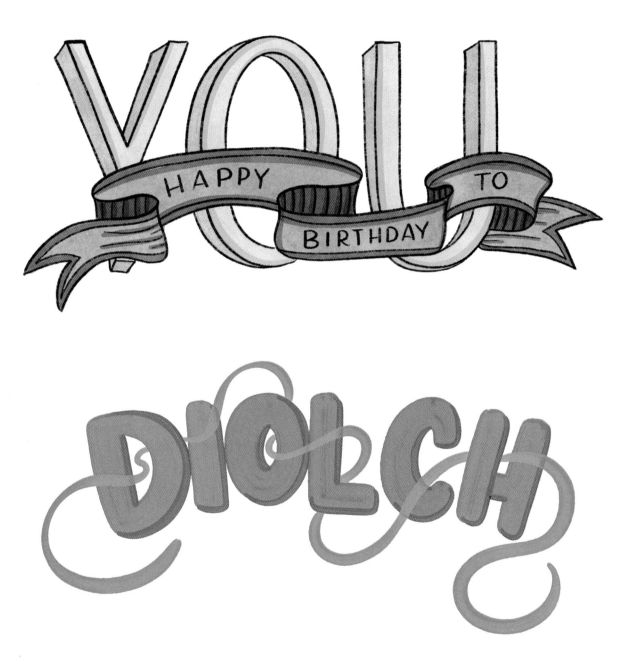

↑ Welsh: Thank you

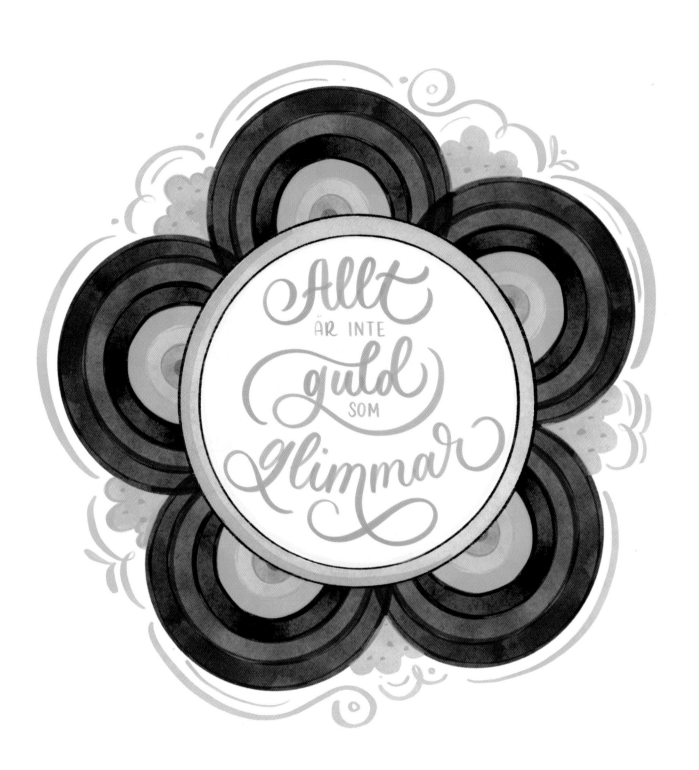

Allt är inte guld som glimmar

· 4 ·

COLORS
AND
BLENDING

Now that you know how to elevate your lettering by adding simple features to create amazing special effects, I hope that you are more confident with your lettering skills. In this chapter, I'll show you how to combine colors from different mediums to create an array of cool effects.

Swedish: All that glimmers is not gold

BLENDING TECHNIQUE 1: BRUSH PEN TIP + BRUSH PEN TIP

Mixing paints is the traditional way to create new colors and gradients. As a beginner, blending can be tricky because mixing colors together can turn your paint muddy and dull. An easy way to jump in when you're just starting out and still learning about the world of combining colors is by using brush pens.

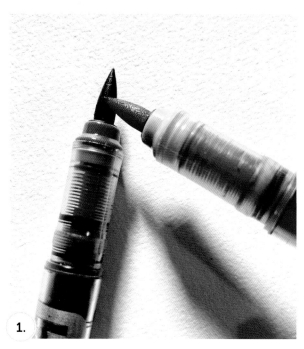

1.

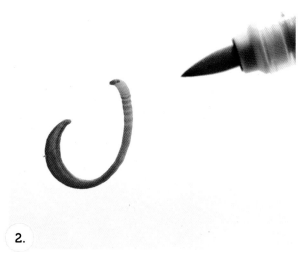

2.

Select two brush pens in different colors. One light shade and one dark shade works best for this. Rub the tips of the pens together so that the darker color transfers to the lighter colored pen.

Next, start writing with your lighter color pen and see how the colors transition and mix from one to the other. This is a good way to initially test whether a color combination works. Because you're not mixing paint, you won't be wasting any supplies, and your brush pens will return to their normal color.

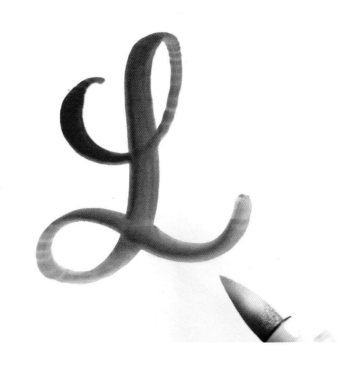

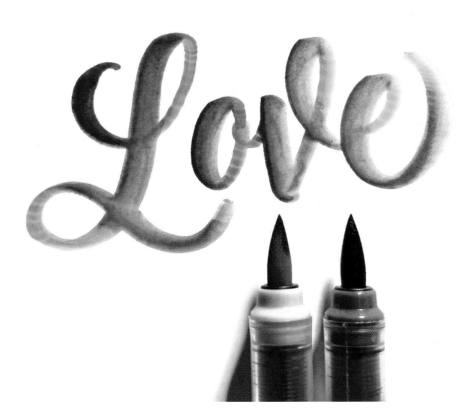

An example of lettering blending brush tip colors.

COLORS AND BLENDING

BLENDING TECHNIQUE 2:
BRUSH PENS + WATER

Here's another way to easily combine colors with your brush pens. For this effect, you must use *water-soluble* brush pens. It will not work with *waterproof* brush pens.

You'll need three different brush pen colors plus a gray brush pen, a watercolor paintbrush, and watercolor paper.

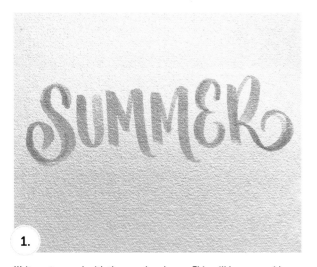

1.

Write out a word with the gray brush pen. This will be your guide and outline.

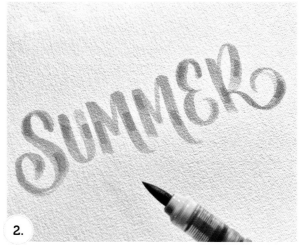

2.

Take one of your colors and draw random marks inside the outline. Be sure to leave ample space between the marks to add the other two colors.

Special Effects Lettering and Calligraphy

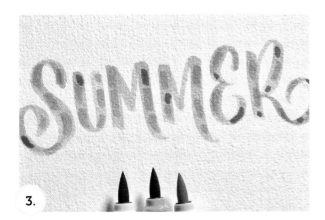

Do the same with the other two brush pen colors until you have all three different colors scattered inside the letters.

Take your watercolor paintbrush, dip it in water, and start painting over the marks, merging the colors together to create a beautiful blended effect.

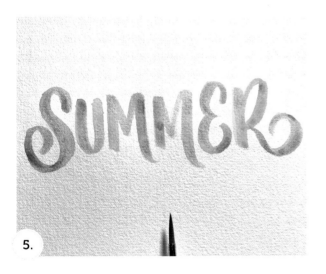

The finished lettering piece.

COLORS AND BLENDING

BLENDING TECHNIQUE 3:
INK + WATER

This special effect doesn't produce something you can frame or that will last. This exercise is mostly for creating *art for art's sake*. When creating artwork, especially hand-lettered pieces, following the rules is important, but so is play! This work may only last for a few minutes, but the process is a lot of fun and can even be meditative.

You'll need a glass pen, water, some coated paper, and watercolor/fountain pen ink.

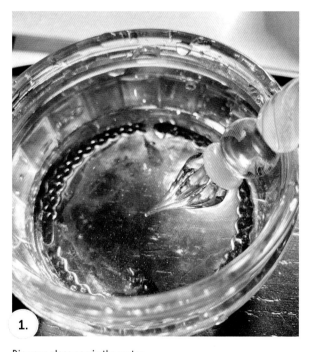

1.

Dip your glass pen in the water.

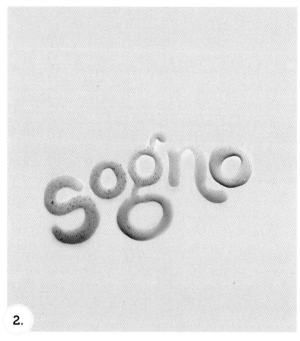

2.

Use the water to write on the coated paper. It's fine if there's a bit of color residue from the last time you used your glass pen because you'll be able to see the water even better.

Special Effects Lettering and Calligraphy

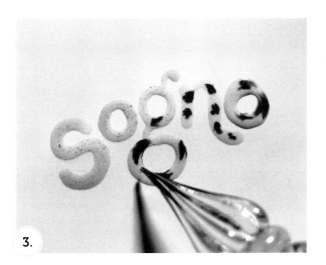

Dip the glass pen in your watercolor/fountain pen ink and carefully dip it back in your water lettering to create a swirly colorful effect on the letters.

3.

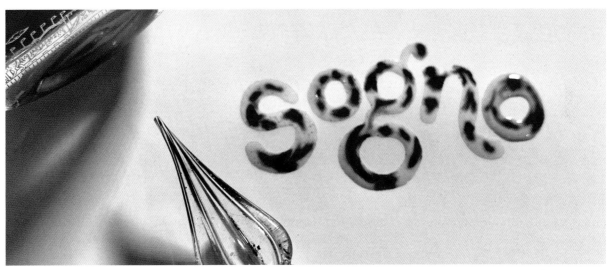

↑ Italian: Dream

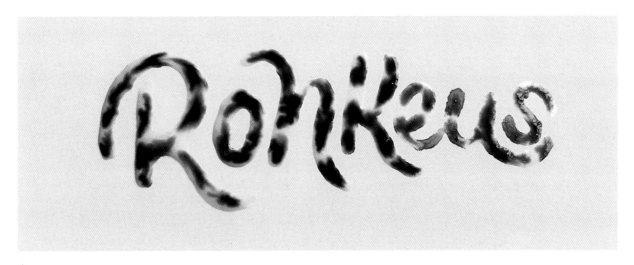

↑ Finnish: Bravery

COLORS AND BLENDING

BLENDING TECHNIQUE 4:
BRUSH PENS + WATERCOLOR INKS

One of the easiest ways to blend colors is by using a brush pen and some bottled watercolor ink. Not only does it take the guesswork out of the process, but you also don't have to worry about the ink contaminating your brush pens. Remember those yellow and black markers as a kid that never went back to their original colors once they mixed? That doesn't happen with this combination of materials, so it's the perfect place for beginners to start and experiment.

For this lettering piece, I used a light blue Pentel Sign Brush Tip Pen and three Royal Talens Ecoline Watercolor Inks. The quote "There is beauty in everything" reminds me of nature and flowers blooming, so I used green to represent trees, orange-red for the sun, and light blue for the sky. I combined two lettering styles, script and sans serif, to create a fresh, modern design.

Not All Bottled Inks Are Created Equal

• • •

Make sure that they are liquid *watercolor* inks. Some liquid inks, like India Ink or acrylic paints, are permanent and won't wash off your brush pen.

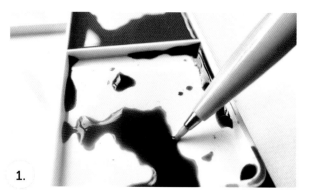

1.

Dip the brush pen in one of the ink colors and start writing. I started with green.

Special Effects Lettering and Calligraphy

2.

The first few letters of the first word will be green. As you write, the colors will slowly blend and change to the color of the brush pen. How long it takes to transition from the color of the ink to the color of the brush pen will depend on how thoroughly you dipped the brush pen tip in the ink.

3.

Once the color has completely transitioned to the brush pen color, you can dip the brush pen in the same color ink or a different color altogether.

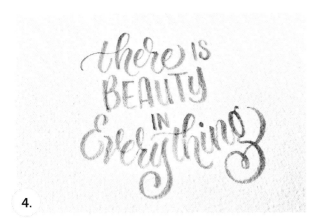

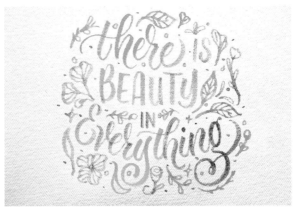

4.

Finish writing the quote, dipping the brush pen into each of the watercolor inks you selected. The quote seemed a little bare, so to finish I added some flourishes, doodle elements, and embellishments to fill up some of that blank space.

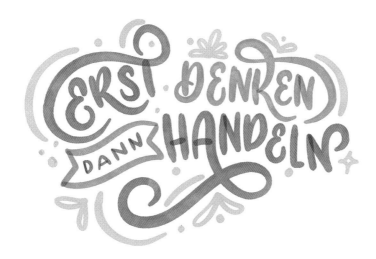

This lettering piece uses a blended colorway of red, yellow, and orange with simple embellishments.
German: Think before you act

Lettering and doodling is a classic combination. The images enhance and complement the meaning and presentation of the word or quote. If you know the basics of drawing letters, it's completely possible for you to also learn how to draw, starting with simple line drawings.

I often create pieces that have one word as the central theme, then surround it with related doodles and flourishes. It's like making artwork out of a mind map! It's a great way to practice generating ideas and learning composition, plus it's also a good first step before you try your hand at conquering longer lettering pieces.

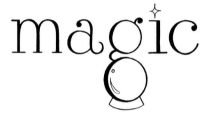

1.

For this piece, I chose the word *magic*, because it's easy for me to visualize images that relate to that word. It's a good idea to start with a word or concept that you find familiar and are comfortable with. I chose a serif style for the word because I wanted the straight, rigid lines to contrast with the flowy lines and flourishes of the doodles.

2.

Look at the shape of the letters and see if you can incorporate any doodle elements with the letterforms. In this case, I chose to use the lower half of the *g* as the basis for a crystal ball. The added doodle is subtle enough that it doesn't interfere with the readability of the word. Plus, the dual role of the *g* as a letter and a doodle works with the theme by creating a sort of diversion and illusion.

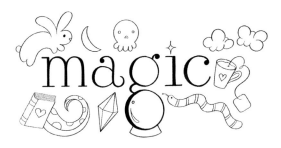

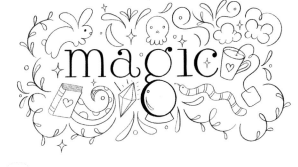

3.

This is where I added all the other illustrations, making sure I left a lot of open space for flourishes and accents.

4.

Here is where all the spaces are filled with tiny design elements. Small dots, curved lines, stars, and water droplets can go a long way to help elevate the central word and the doodles.

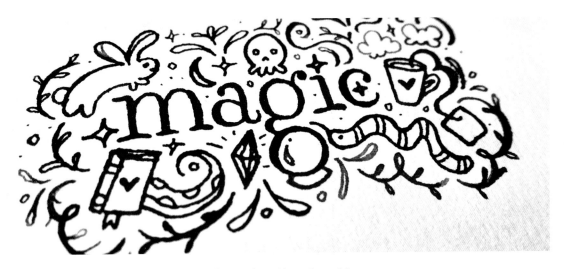

↑ The finished piece, which I made using a glass pen and different colors of fountain pen ink.

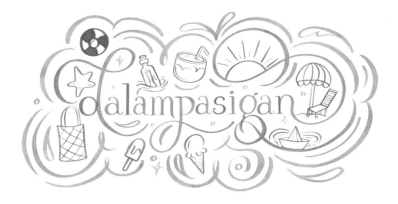

↑ Tagalog: Beach

ADDING METALLIC COLORS

There's something exciting and uplifting about using shiny ink, and there's nothing better than glittery watercolor to create an out-of-this-world effect.

For this piece, I used a similar process of outlining as when I combined colors with the brush pen and water (see page 100). Make sure you have a gray brush pen at hand in addition to the metallic paints.

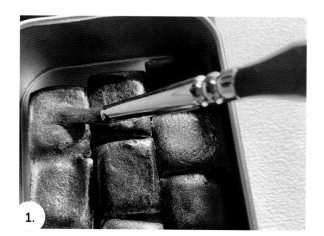

Use the gray brush pen to create the outline of your word.

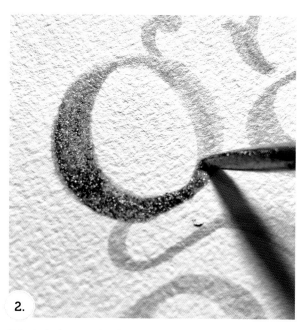

Color in the letters using the metallic colors from the palette.

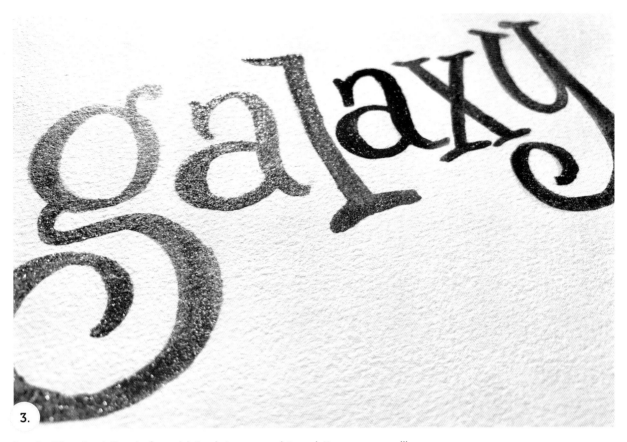

3.

I used a different metallic color for each letter, but you may paint your letters any way you like.

COLORS AND BLENDING

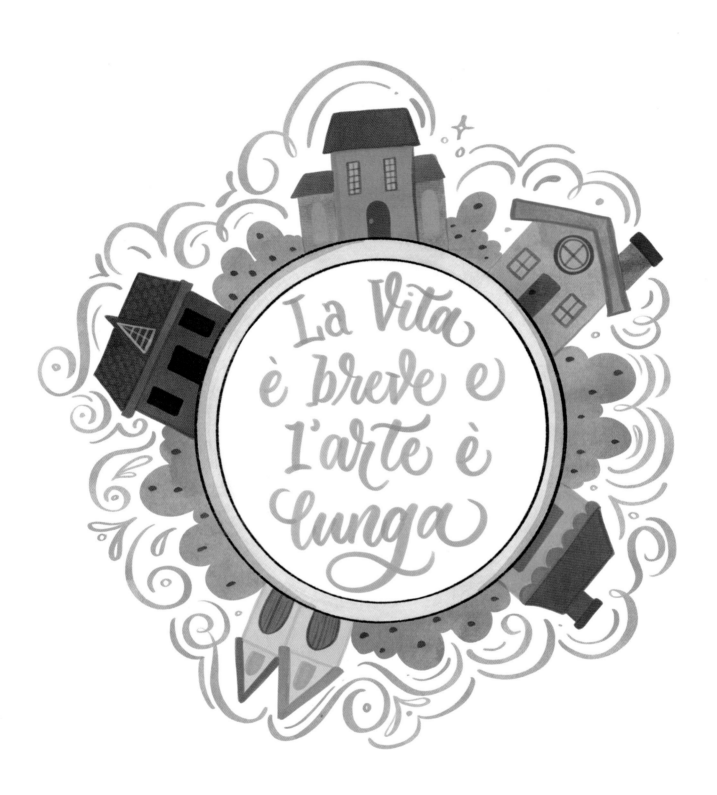

· 5 ·

OODLES
OF
DOODLES

In this chapter, I'll show you how to draw simple illustrations and add them to your lettering pieces.

← Italian: Life is short and art is long

ANYONE CAN DOODLE

Even if you think you can't draw—believe me, you can! Just start by following these very simple steps. Every time I think that something is too complicated to doodle, I envision this process so that it makes things easier to break down and organize them in my head. *Everything starts with a dot.*

1.

Start with a dot.

2.

Add a bunch more dots.

3.

Connect the dots and create a line.

Experiment with the line and get creative.

Make it wavy.

Do a zigzag line.

Add curves.

Add curls.

Make uneven strokes.

4.

5.

Next, draw some shapes.

6.

Combine the lines and shapes to create patterns.

BUILDING UP WITH SHAPES

Every doodle or illustration is just a combination of shapes. If you see an image that you want to re-create, try to build each element from its individual shapes. It's almost like trying to re-create a dish without a step-by-step recipe right in front of you. Because these are simple line illustrations, they don't have to be realistic or lifelike. They don't even have to look exactly like the doodle that you're trying to replicate. One of the advantages of not having to follow a guide is that you'll end up adding your own unique element to what you're drawing.

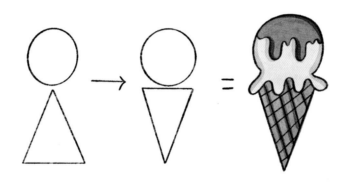

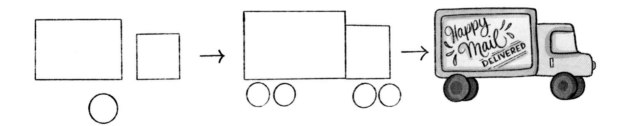

BREAKING DOWN INTO SHAPES

This process also works in reverse. One of the most frustrating things about being an artist is having a clear picture of what you want to draw in your head, but every time you try to put it down on paper, your hand just doesn't want to cooperate. At this point, I usually throw my notebook across the room in annoyance. But during my clearer moments, I try to take a pause and start building the drawing one shape at a time. I think about what sort of simple patterns, shapes, and lines I could use to build my drawing.

Start your doodling journey by practicing with the doodles on the following pages. Here are some ideas for how to use the doodles shown in the next pages:

1.

Trace them until you're used to creating the illustrations.

2.

Try the breaking down shapes and/or building shapes methods.

3.

Re-create the basic shape of the doodle and add your own details to it.

CREATING DOODLE PATTERNS

Now that you've practiced doodling and have some basic go-to illustrations you can use when creating different types of artwork, let's test it out with this doodle pattern activity.

One of the things I enjoy doing is combining all the simple doodles and fitting them in one page, creating a pattern. It can be used as a postcard, a coloring page, or even as gift wrapping paper. I've gotten so used to creating this type of artwork that I can do them freehand. Here's a step-by-step guide of my process when I first started out.

1.

It's helpful to begin with a theme. I chose to do a brunch-themed doodle page. Draw some random shapes across the page. Don't worry if you can't fit them all properly or if there are spaces that you can't fill.

2.

Now comes the fun part! Remember how we broke down and built up shapes earlier? Try to fit doodles in the random shapes that you have made. This is a fun little exercise on creativity. But don't feel like the random shapes you made are final. You can always adapt and expand as you go along.

Special Effects Lettering and Calligraphy

3.

Add some little embellishments around the doodles you made to fill up the empty space around the page.

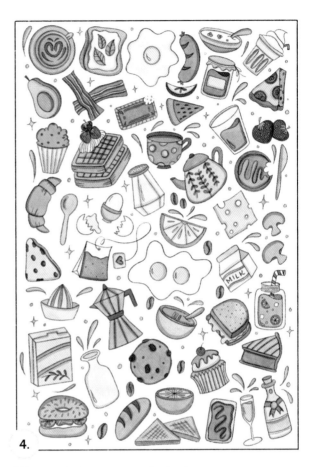

4.

Add some color to your new masterpiece!

There are a lot of different ways that you can seamlessly combine lettering and illustration.

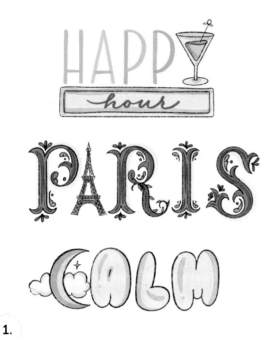

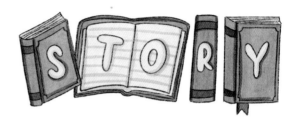

1.

Replace a letter with a doodle. Some letters have the same shape as some doodles, and replacing one or two letters will add a fun element to your artwork.

2.

Placing the lettering components inside the doodles is an easy way to combine both elements. This way, you won't need to worry about how to place each separate element on the page.

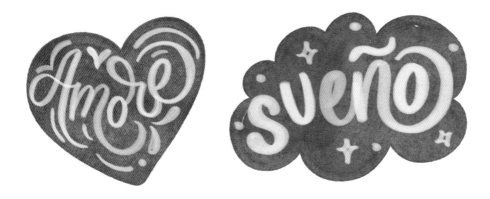

3.

Doodle a basic shape and fill it in with color to create a silhouette. Next, add your lettering inside the colored-in shape. Fill in the shape by adding flourishes and embellishments.

An example of a piece that combines all three of these techniques.

DRAWING BANNERS

Drawing banners, frames, and ribbons is an important part of combining doodles and letters. There are different ways to draw banners, from simple to complicated ones. Once you know how to do the basic banners, it's easy to expand to create elaborate ribbons. Practice with this step-by-step guide first and then use the next page as reference to create your own.

DOODLE BANNERS, STEP-BY-STEP

BANNER 1

1. Draw two short and wavy parallel lines.

2. Add triangular brackets to the ends of the lines. You can also change this to straight, wavy, or curved if you want a different look.

3. Add broken lines to the top and bottom of the ribbon.

BANNER 2

1. Draw a wavy line with two curves in the middle.

2. Add a short line below the lower curve that you drew. This will determine the length of the ribbon.

3. Add two matching, wavy lines and make sure they are the same length as the lines on top.

4. Add triangular brackets to the ends. Add short lines on the first curve. This will be the back of the ribbon.

Special Effects Lettering and Calligraphy

BANNER 3

1.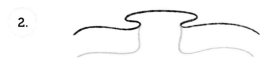

Draw a wavy line with two curves on either side of the middle curve.

2.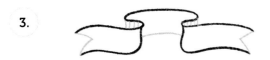

Add lines below the right and left parts. Make sure they are the same length.

3.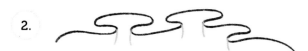

Add triangular brackets to the ends. Add a slightly curved line in the middle. Add short lines to show the back of the ribbon.

BANNER 4

1.

Experiment by creating a wavy line with curves in different directions.

2.

Add lines to all the lower curves.

3.

Add matching wavy lines of the same length.

4.

Add triangular brackets and lines to show the back of the ribbon.

5.

Add short lines for detail.

↑ An array of different banner types.

Special Effects Lettering and Calligraphy

EMBELLISHMENTS

Here are some extra little touches to enhance your doodles and lettering.

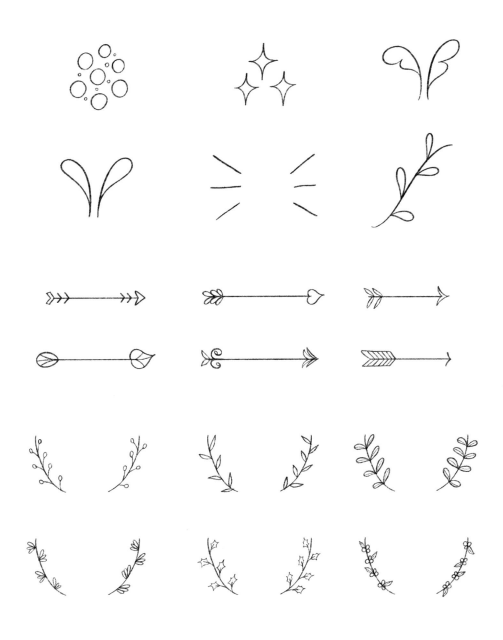

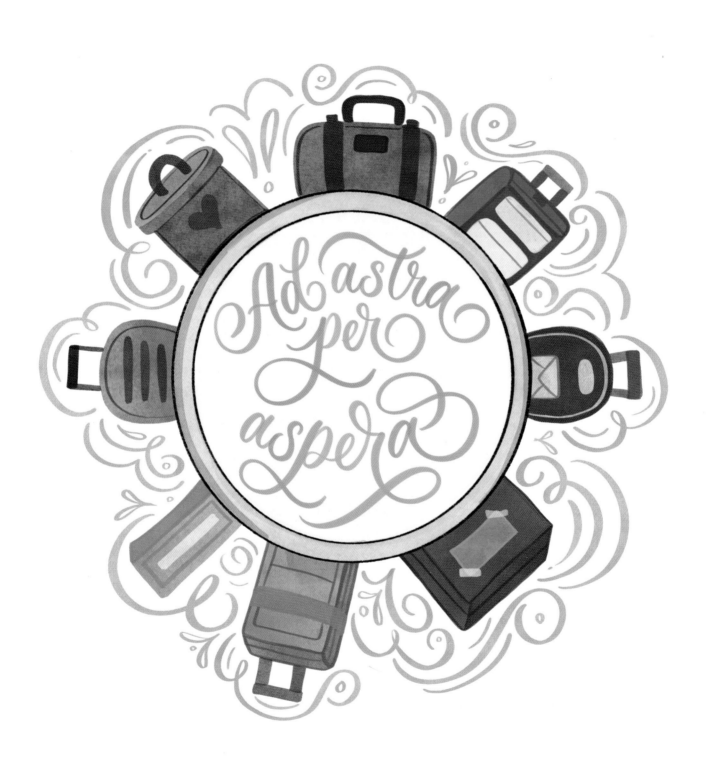

· 6 ·

PUTTING IT ALL TOGETHER

Now that we have all the design elements needed to create beautiful art pieces, it's time to put everything together. Knowing different types of letterforms, doodles, and special effects opens up a world of possibilities. Soon enough, you will be able to use them to create amazing posters, eye-catching greeting cards, or even illustrated storybooks.

Latin: To the stars through difficulties

When I write longer art pieces that incorporate both lettering and illustration, I usually start with a quote already in mind. The next step is creating a layout that can organize all these different pieces and make them fit on the page like a puzzle.

CREATIVE EXERCISE: FROM LAYOUT TO QUOTE

Sometimes, I also like to warm up and challenge myself by doing these two steps in reverse. I draw layout boxes first and then think of a phrase or a quote that would fit in them.

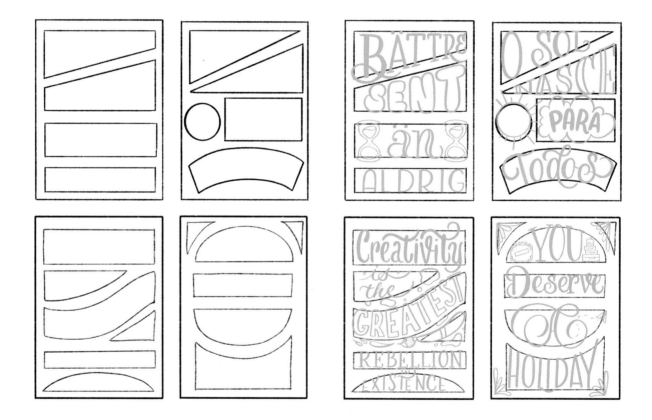

↑ A few examples of various layout boxes. Have fun with them!

↑ A sampling of short quotes that fit a variety of configurations.
(Top left) Swedish: Better late than never
(Top right) Portuguese: The sun rises for everyone

Special Effects Lettering and Calligraphy

Here's an example of this creative technique, starting with the quote first, that you can try.

"so much universe and so little time"
—TERRY PRATCHETT

1.

Think of a quote that you would like to letter and illustrate. If nothing immediately comes to mind, choose quotes that you can visualize and represent with doodles. For this example, I used a quote about space because I know I can use certain doodle elements that I enjoy drawing.

"so much universe and so little time"
—TERRY PRATCHETT

2.

Think about which words in the quote you want to highlight that are the most important. You'll want them to appear bigger in your lettering illustration piece.

STARS ASTRONAUT
SPACE CLOCK
PLANETS SAND TIMER

3.

Look at your quote and think of images associated with it. You're going to want to fill up the page with both letters and doodles, so having a collection of ideas ready will be very helpful once you start composing and laying out your piece.

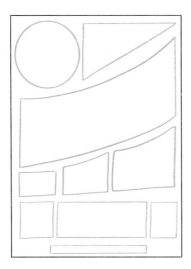
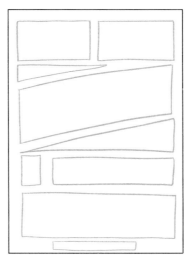

4.

Just as in the Building Up with Shapes exercise earlier (see page 114), you can use the same technique with this lettering illustration piece. Create boxes around the page with the same number as your words, plus some extra ones if you already have doodles in mind.

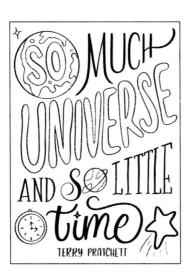
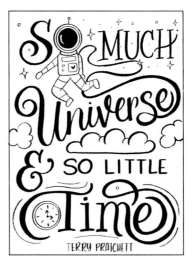

5.

Start laying out all the different elements. Think of all the various lettering styles and incorporate some of your favorites into the artwork.

Special Effects Lettering and Calligraphy

On this page are four different examples of how I interpreted the same quote.

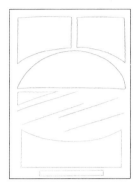 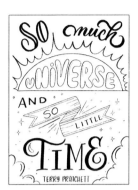

 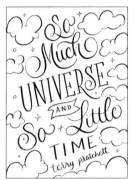

 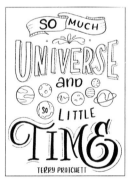

 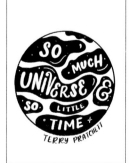

133

Here are some examples of longer lettering pieces. Try making similar works using your own quotes.

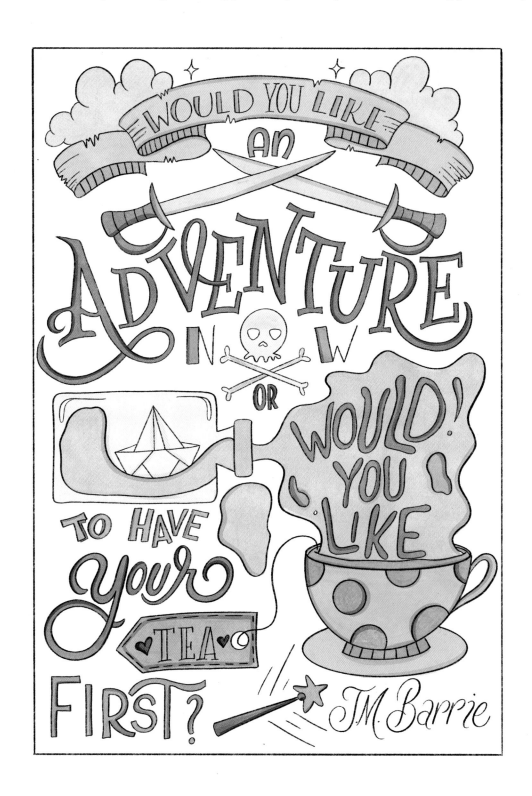

↑ A longer lettering piece from *Peter Pan* by J. M. Barrie incorporating illustrations that complement and enhance the subject.

Special Effects Lettering and Calligraphy

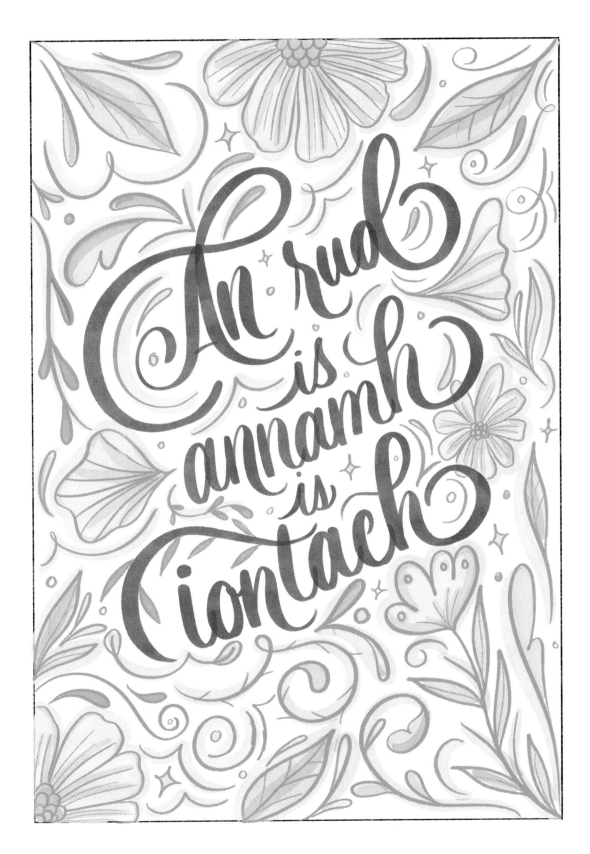

Irish: What is seldom is wonderful

PUTTING IT ALL TOGETHER

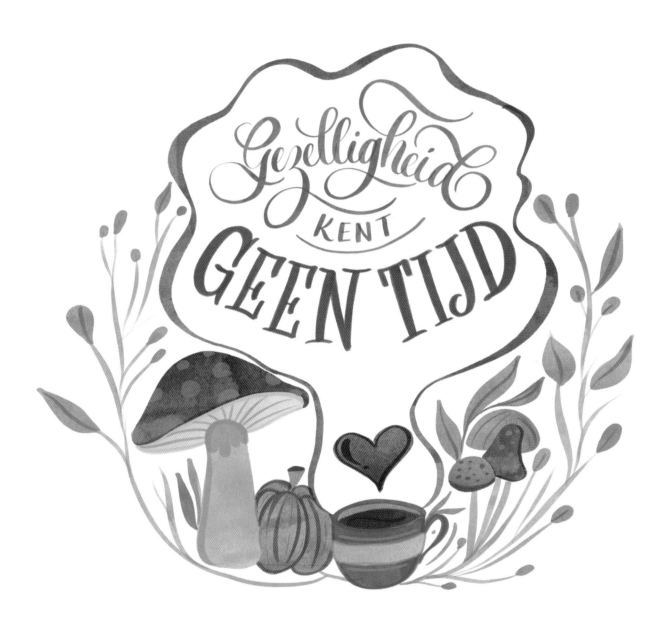

↑ Dutch: Coziness knows no time

Special Effects Lettering and Calligraphy

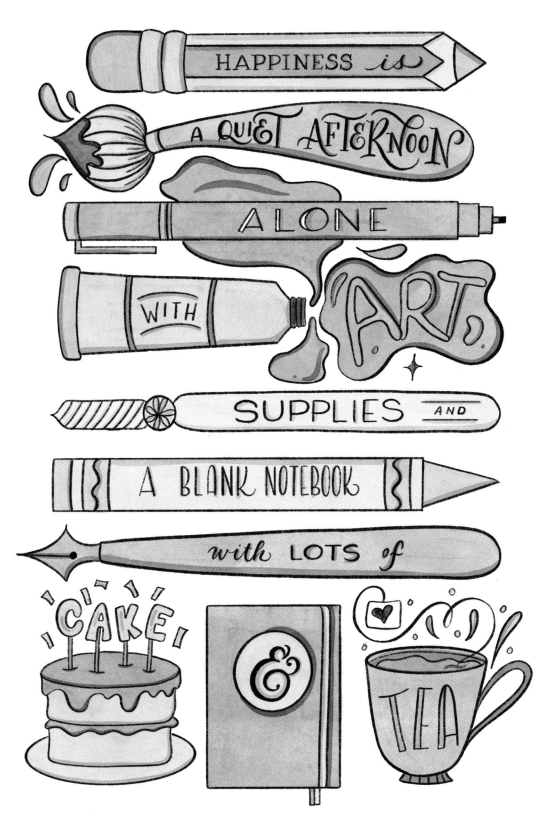

HAPPINESS *is* A QUIET AFTERNOON ALONE WITH *ART* SUPPLIES AND A BLANK NOTEBOOK *with* LOTS *of* CAKE & TEA

A piece combining different lettering styles and doodles about my love for art and art supplies.

137

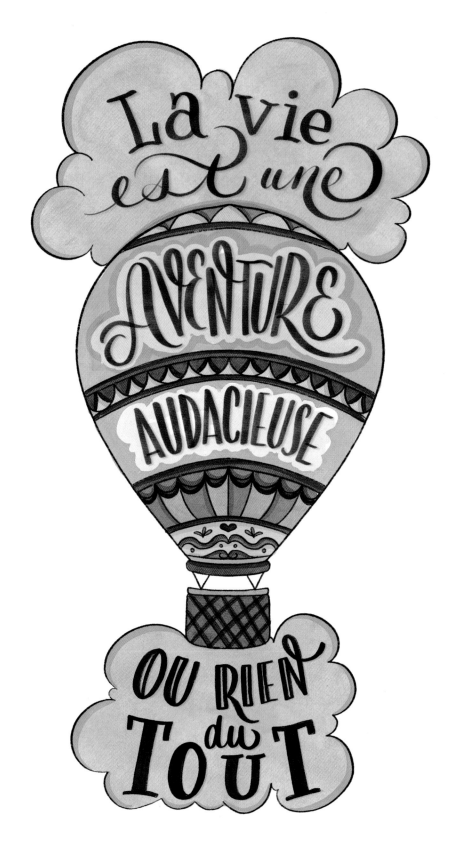

↑ French: Life is a daring adventure or nothing at all

Special Effects Lettering and Calligraphy

RESOURCES

RECOMMENDED ART BRANDS

Faber-Castell
https://www.faber-castell.com/products
For Brush Pens, Colored Pencils, and Dust-Free Erasers

Ferris Wheel Press
https://ferriswheelpress.com/
For Fountain Pen Ink

Karin Markers
https://www.karinmarkers.com/en
For Brush Markers and Metallic Gel Pens

Koh-I-Noor
https://www.koh-i-noor.cz/en/about-us
For Rainbow Colored Pencils

Pentel
https://www.pentel.com/
For Brush Markers

Reneeissance Colours
https://www.etsy.com/uk/shop/ReneeissanceColours
For Metallic Watercolor Paints

Sakura
https://www.sakuraofamerica.com/
For Fineliners and Gel Pens

Uni-ball
https://uniballco.com/
For Mechanical Pencils and Writing Pens

Wancher
https://www.wancherpen.com/
For Glass Pens

WHERE TO FIND ME AND MY WORK

Instagram
https://www.instagram.com/gracecallidesigns

Tiktok
https://www.tiktok.com/@gracecallidesigns/

Domestika Online Class
https://www.domestika.org/en/courses/2654-creative-doodling-and-hand-lettering-for-beginners

Etsy Online Store
https://www.etsy.com/shop/gracecallidesigns

ARTISTS TO FOLLOW ON INSTAGRAM

@thepigeonletters
@artbyeringrace
@lighttheskyarrs
@matvoyce

@homsweethom
@plansthatblossom
@inkandlise
@everytuesday

@letteringwithsuzy
@lyssas_letters
@sevenbrushstrokes
@farah.brightart

I never thought I would ever make art for a living, let alone have the incredible opportunity to write a book. This process has been equal parts exciting, terrifying, and a real test of self-confidence. I feel so fortunate to be able to do this and none of this would have been possible if it weren't for the people who have helped me along the way.

To my favorite person in the world, my husband, Joonas. You have been my tireless supporter, greatest cheerleader, and maker of endless cups of coffee. I love you and thank you for everything!

To my amazing friend, Renée who is always there whenever I need encouragement, jokes, or a day out at the theatre. I'm so thankful that we crawled out of our respective introvert shells and started hanging out together.

To my coffee buddy, Tim. Thank you for your constant support and occasional wake-up calls, especially during the times I wanted to give up.

To my sisters, Gen and Garla. Thank you for the support and boundless excitement about all my art projects.

To our game friends, Jack and Julia, thank you for the support, advice, and company.

To everyone at Quarto and Quarry Books. A special thank you to Joy for guiding me through this process and for initially giving me the opportunity to write this book. I am eternally grateful.

Thank you to Gabrielle, for the patience and understanding while I scrambled to get everything together. To Lydia, thank you for your contagious enthusiasm and expertise in helping me share this book to everyone. To David, for helping me with the art direction of the book.

To my family and friends scattered across the world in the Philippines, Finland, the USA, and Dubai. Thank you for the support.

A special thank you to my internet friends: Monica, Claudia, Marina, Emilie, Venus, Shaa, and the community at Planner Adventures.

To my patrons, thank you for your support through this process. I wouldn't have been able to take on this huge project if it weren't for you.

Thank you to Mark Escaler, my graduate school teacher, who unknowingly sparked the flame and encouraged me to start making art just by asking the question "We all knew how to draw as children, why do most of us stop when we're adults?" In class one day.

To our cats, Domino and Jammy, thank you for staying up with me during the late night writing.

And many thanks to you, for buying this book. It has been my dream to create something like this and I feel very lucky I was able to do so. Whether you have been a longtime follower or a new one, I appreciate the support from the bottom of my heart. I hope this book helps you in your creative journey.

ABOUT THE AUTHOR

Grace Frösén is a lettering artist and illustrator with a popular following on Instagram @gracecallidesigns. In addition to selling her doodle and lettering workbooks on her Etsy site, GraceCalliStudios, Grace teaches a creative lettering class on the online teaching platform Domestika. Originally from the Philippines, she lives in Cambridge, UK.

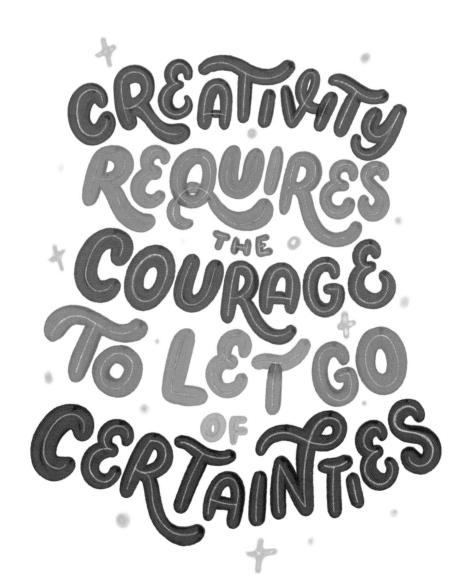

 # INDEX

Special Effects Lettering and Calligraphy

Special Effects Lettering and Calligraphy